PORTRAITS OF
Pregnancy

To all my mothers, whose generosity, support,
and trust brought this book to life.

First Sentient Publications edition 2009
Copyright © 2009 by Jennifer Loomis

A paperback original

Cover design by Kim Johansen, *Black Dog Design*
Book design by Sandra Eisert and Kim Johansen
All photographs by Jennifer Loomis

Library of Congress Cataloging-in-Publication Data

Loomis, Jennifer, 1968–
 Portraits of pregnancy : birth of a mother / Jennifer Loomis and Hugo
Kugiya. -- 1st Sentient Publications ed.
 p. cm.
 ISBN 978-1-59181-082-7
 1. Pregnant women. 2. Motherhood. 3. Pregnancy--Pictorial works. I.
Kugiya, Hugo. II. Title.
 HQ759.L578 2009
 306.874'30922--dc22

 2008052271

Printed in the United States of America

10 9 8 7 6 5 4 3 2 1

SENTIENT PUBLICATIONS
A Limited Liability Company
1113 Spruce Street
Boulder, CO 80302
www.sentientpublications.com

PORTRAITS OF
Pregnancy

THE BIRTH OF A MOTHER

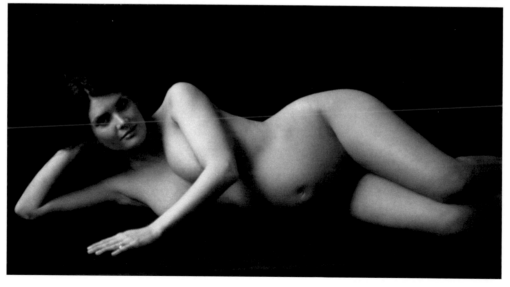

JENNIFER LOOMIS
and Hugo Kugiya

Contents

Foreword

STORIES AND ARTISTIC RENDERINGS OF PREGNANCY AND MOTHERHOOD have captivated women and men from all cultures, races, religions, and ethnic groups throughout history. In art through the ages—paintings, sculpture, and other artifacts—images of pregnancy, birth, mothers, and babies abound. Folklore, advice, rituals, and symbols have also served to celebrate fertility and preserve safe passage of mother and baby through the process of giving birth and being born. Though society and culture has evolved, the basic truth remains that motherhood continues to occupy a central position of importance in today's culture.

Jennifer Loomis and Hugo Kugiya have combined their extraordinary talents to add a powerful contemporary perspective to the vast body of art on this subject. Jennifer's striking and sensitive photographs of pregnant women and new mothers are accompanied by Hugo's honest and revealing retelling of the women's widely varying stories. These combine to capture both the inner and outer beauty of modern motherhood, including all its challenges and triumphs.

Every pregnant woman, every new mother, has a story to tell, and each story is unique and fascinating and compelling—if, as Jennifer and Hugo did, one takes the time to really look and listen. In this book, we meet women from sixteen to fifty-four years old and from all walks of life, many of whom encountered a wide

range of challenges that they overcame as they were becoming mothers. The balancing act of motherhood and career, making time for a baby, infertility, early abuse and neglect, unwanted or unplanned pregnancy, repeated miscarriage, twins, single parenthood, postpartum depression—these are just some of the factors that these women had to deal with. Reading about their successes is inspiring and empowering for everyone.

Jennifer's mission is to use her keen eye and artistic talent to reveal the beauty and spirituality in every woman in the childbearing phase of her life. Her compelling and sensitive photographs capture the mystery of the everyday miracle of motherhood. Hugo's mission is to clarify the change in focus that necessarily comes with successful parenthood, from self-centered values to child-centered values. Study the photos and take in their message, then read the stories and quotes to deepen your own appreciation of these women and of the transformative power of motherhood.

The message of this book is inspiration. These women have opened their hearts and shared personal and emotional moments from their journey to becoming mothers in the hopes that their stories will give strength to other women. The book touches us and reminds us of both the needs and the strengths of our most vulnerable citizens—mothers and babies—in a most heartfelt and sensuous manner.

—Penny Simkin, PT, CD (DONA), author of *The Birth Partner*

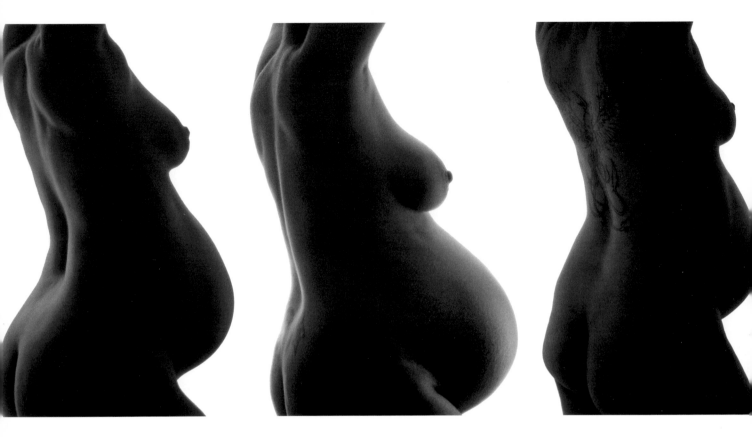

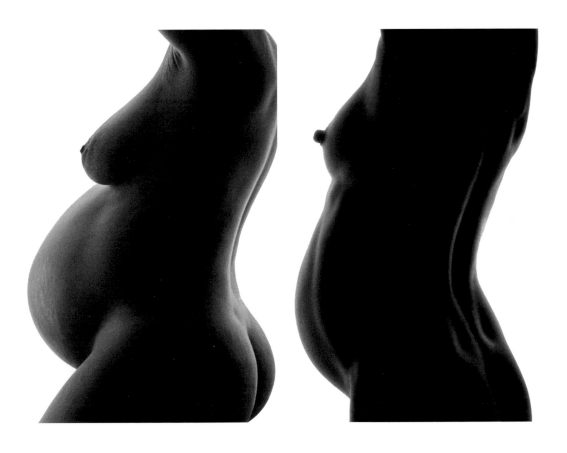

Introduction

\mathcal{I}N 1992, AT THE AGE OF TWENTY-FOUR, I WALKED INTO ONE OF MY FIRST photography classes with my old Pentax slung over my arm and no idea that photography was going to become my passion, my life, and my business. As I looked around, I noticed I was the only woman in the room.

The subject of the class was female nudes. As the teacher started to talk, a model posed against a black backdrop. With a single light providing shadow and contrast, she did a backbend then slowly moved into different poses. Stunned and amazed, I couldn't take enough photos; I just kept going, seeing only the shape of her,

marveling at the simplicity of her form. I had goose bumps. It reminded me of the feeling I had when I first saw the Mapplethorpe photographs of Lisa (the female bodybuilder who posed Eve-like with a python). When I became aware of my surroundings again, I realized my other classmates weren't feeling my enthusiasm. They were snapping the occasional shot, but I thought they seemed kind of bored.

The class took a break and when we resumed, the black backdrop was gone, replaced by a chair on a stark, gray stage. Seated backward in the chair was my once-beautiful model, now dressed in ripped fishnet stockings, a garter belt, and a corset. "What's going on here?" I thought, horrified. A glance at the syllabus quickly explained the focus of the second half of the class was boudoir photography. I heard noise and looked up to see nine male photographers in a frenzy, their motor drives feverishly trying to keep up with their fingers. It was at this moment that my life changed. I realized there weren't enough women photographing women. I grasped the fundamental difference between those men and myself in how we viewed women's bodies. I went home and called all my female friends and asked them to pose for me. Thank God they said yes.

Every now and then, I am mystified by my success, incredulous that my full-time job is photographing pregnant women and their families. Because right after that revelation years ago, I, a motivated and industrious girl, did numerous informational interviews with professional photographers in the San Francisco Bay area asking them how to get started photographing nudes of women and subsequently pregnant women. Not one of them encouraged me. I received only this advice: "No one is going to pay you to photograph women nude and certainly not nude and pregnant. You should go back to school and study photojournalism. Then at least when you get out, you can get a real job working for a newspaper." I thought, "Yeah, you're right. Silly idea."

It was at this moment that my life changed. I realized there weren't enough women photographing women. I grasped the fundamental difference between those men and myself in how we viewed women's bodies.

So I got my master's in photojournalism from the University of Missouri. It was great. I used my camera to tell stories that changed people's lives. I worked for several papers in the Midwest. I went to Japan and focused on the aging populations in nursing homes; I moved to Kenya, photographing East African women who were starting small businesses, and HIV-positive prostitutes who were rebuilding their lives. I traveled throughout Uganda, Rwanda, Kenya, and Tanzania for CARE and numerous editorial publications. My camera changed their lives, it changed the lives of my viewers, and it changed me. I found a deep level of compassion, and I connected with my burning desire to make a positive impact on this world. I was happy, making a difference, and eking out a living—albeit barely. Plus, I was still photographing nudes of women and pregnant women in all my spare time.

Then MSNBC.com asked me to join its multimedia team in Seattle and help build the website's visual offerings. It was a cutting-edge job, but I wasn't photographing as much as I had hoped. So after three years I decided to give it up and start my own business. It was something I had always wanted to do. And I wanted to get started before I became unable—trapped by debt, family responsibilities, or fear. I got the confidence boost I needed to quit when the Bill and Melinda Gates Foundation hired me in October 2001 for my first big contract. My plan was to start a business telling stories on the Web for nonprofit organizations, using audio, photos, and video. So I refinanced my mortgage, borrowing $14,000 against my house. I gave my notice at MSNBC.com on September 7, 2001—four days before September 11.

Like so many industries, my small business suffered after that day. For the next six months, my office was a quiet place. No constantly ringing phones, no hum of machines. I had a lot of free time to think about ways to grow my business and, more urgently, pay my mortgage. I had always loved maternity photography, so I

11

*I had a lot of compassion for the women
who came into my studio struggling
with their new curves. I began to
realize that pregnancy photography
could help women see their bodies
in a new way—as beautiful.*

thought it would be a great idea to pursue while waiting for the big nonprofit contracts to roll in.

I found there were no photographers doing this kind of work, or at least none advertising this kind of work in Seattle. At that point, there were also few pregnant women in advertisements or on magazine covers. So with no particular budget, I embarked on what I called my guerrilla marketing project, putting up some of my beautiful photographs of pregnant women in places they frequent, figuring they would want to have those types of photographs taken of themselves. I was right. That once-quiet phone started ringing. But I only intended this work to generate part-time income.

To give a boost to my documentary business, I once again embarked on informational interviews, meeting with a videographer at NBC, who asked me, "Hey, don't you photograph nudes of pregnant women?" Stunned that he knew about this, I said, "Yes, but please don't tell anyone." I didn't want any of my clients from the Gates Foundation to know, thinking it would be bad for business.

"I think this is a great Mother's Day story," the videographer told me. "Will you let me pitch it?" Reluctantly, I agreed and the story aired. Little did I realize, a baby boom was under way. September 11 had brought focus back to the family for many Americans. My phone rang off the hook after that story aired and my new business, Jennifer Loomis Photography, changed its priority to maternity and family photography.

Feel Beautiful

When I took that leap and went out on my own, I didn't consider the impact I would have on this genre of photography. I have now been capturing pregnant

women on film full-time since 2001, and I have no regrets about leaving daily journalism. Each time I create a photograph that captures the exquisiteness and spirit of a mom-to-be I anticipate showing it to my client who will often say, almost surprised, "Wow, I look beautiful." This alone makes the risk of working for myself worth it.

Having struggled with an eating disorder as a teenager, and finally overcoming it when I was twenty-one, I understood how losing control of your body, for any reason, can be both a terrifying and liberating experience, if you allow time to truly see yourself. I had a lot of compassion for the women who came into my studio struggling with their new curves. I began to realize that pregnancy photography could help women see their bodies in a new way—as beautiful. If they could feel that way when they were pregnant, no doubt they would be able to continue to see their unique beauty for the rest of their lives. The more women I photographed, the more I heard the same thing: "You made me feel so beautiful."

My business motto, "Feel Beautiful," was not the product of extensive market research. It came from all the mothers throughout the years, and I heard it over and over again in many different voices:

"You make me feel so beautiful."

"I feel like I am the most beautiful pregnant woman you have ever photographed."

"I knew if anyone could do it, you could make me feel and look beautiful."

"I came to you because I want to feel beautiful."

"I have had a terrible time during this pregnancy, and I wanted for one day to feel beautiful."

There are so many more. For all of them, my photography shaped how these women saw themselves when they were as big as they would ever be.

From Darkness to Light

Women today are engaging issues of body image with increased confidence, fueling a greater curiosity about pregnancy and its power in the public realm. Since the beginning of the 1990s, there has been a distinct societal shift; pregnant women are now seen in magazines and advertisements and on TV. Former NBC anchorwoman Campbell Brown, plainly and unabashedly pregnant, conducted a serious interview on national television not hidden behind a desk, but standing, her bulging belly in full view. Moms-to-be feel empowered to wear tighter, more revealing clothes and to show off their changing figures. But this was not always so.

When my grandmother was pregnant, she told me, people used to cross the street when she approached so they wouldn't have to pass her on the sidewalk. Pregnant women were rendered invisible: pregnancy was something to be kept secret and private. This attitude prevailed even as I started my business. The women who came to me didn't tell their friends or family because they were almost embarrassed they were having photos taken of their bodies.

My mission is to bring the pregnant body directly into society's gaze. When I was selected as a premier photographer for a show in Seattle featuring Northwest artists, I enlarged four photographs of nude, pregnant women of different races and hung them in the window of the gallery. Then, I sat on the couch in the gallery, watching people go by on the street. Most walked past, then came back, stopped and stared into the window, marveling at the pregnant torsos. Many who stopped to look were men who wore looks of confusion: she's beautiful, but she's pregnant; that body is beautiful, but it is pregnant.

The taboo of public displays of pregnancy was perhaps first broken in the pop-culture realm by Annie Leibovitz, whose pioneering but controversial 1991

photograph of a very pregnant Demi Moore graced the cover of *Vanity Fair*. Conversation about pregnancy extended beyond doctors' offices and into living rooms as Oprah Winfrey and other talk show hosts began to look at the expectations and misconceptions surrounding this sometimes mystifying nine-month period.

Celebrities like Demi Moore, willing to step into the spotlight with their pregnant bellies, may have fueled this widening of attitudes about pregnancy. But all pregnant women, famous or not, are continuing the process, walking proudly, sensuously, reflecting confidence and power. My job is simply to show them their own beauty. And they see it, sometimes for the first time.

We all form opinions of our bodies—mostly subconsciously, often in an imperfect if not inhospitable climate—absorbing the messages we get from our parents, our peers, and, of course, the media. Rewriting the negative aspects of those messages, that code, can be difficult and requires a safe and supportive environment, one that I strive to create.

In this book we celebrate the beauty of the pregnant form as well as the incredible transformations that occurred within each woman we interviewed. It is my hope the images and stories will cause all pregnant women to appreciate their bodies and their journey to motherhood in a new way, that they may be able to garner strength from the words of these women who have undergone the deep transformation to mother. I believe that the book will teach others too, like those men who stopped to look at my pictures through the window. This is only the beginning of a larger change, led by many of these women, in how our society perceives the pregnant body. For when a child is born, so is a mother.

—Jennifer Loomis

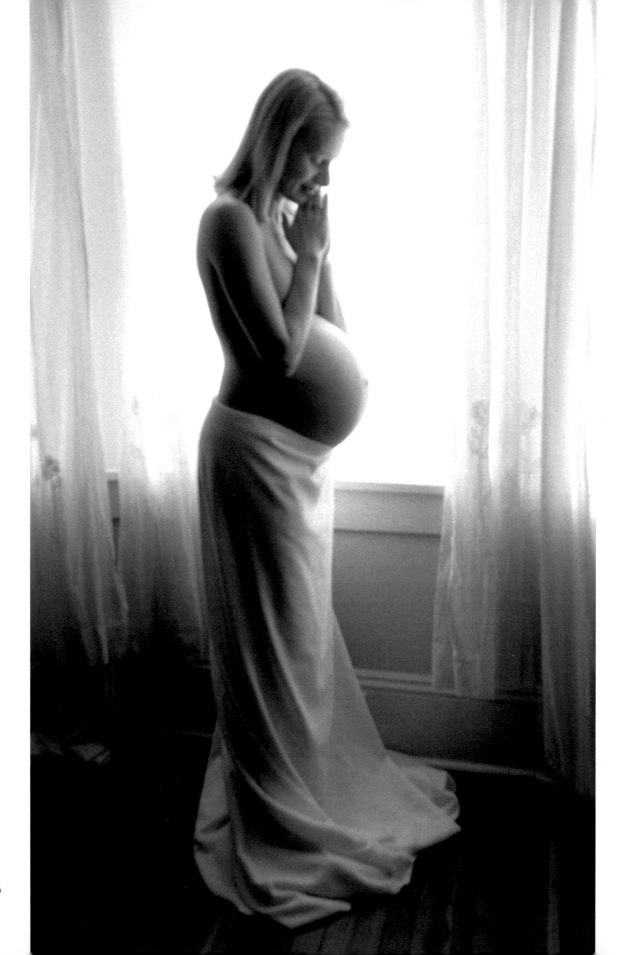

KRISTIN

W OMEN WHO HAVE BECOME MOTHERS KNOW THAT IT ISN'T always a glamorous process. We know what it takes to grow a child—you give up something of yourself to make room for another. I loved being pregnant with Estelle. It was a sweet, intimate knowing. Someone special was growing inside, and I was the one blessed to carry her. When I found out I was carrying a girl, after two handsome boys, I cried. I realized how much I wanted a girl to share all those distinctly female experiences with. I felt blessed and whole with this special time to love a little someone I hadn't even laid eyes on, but already knew in my heart.

SARAH

I WAS GOING THROUGH THIS ENTIRE PREGNANCY SOLO AND many days were difficult to get through. But at the same time, I felt so empowered because I was doing this on my own. I also made sure that during this pregnancy my daughter bonded deeply with her unborn brother. I wanted her to feel like she was a very important part of this process and her help was essential to make his coming to this world very special.

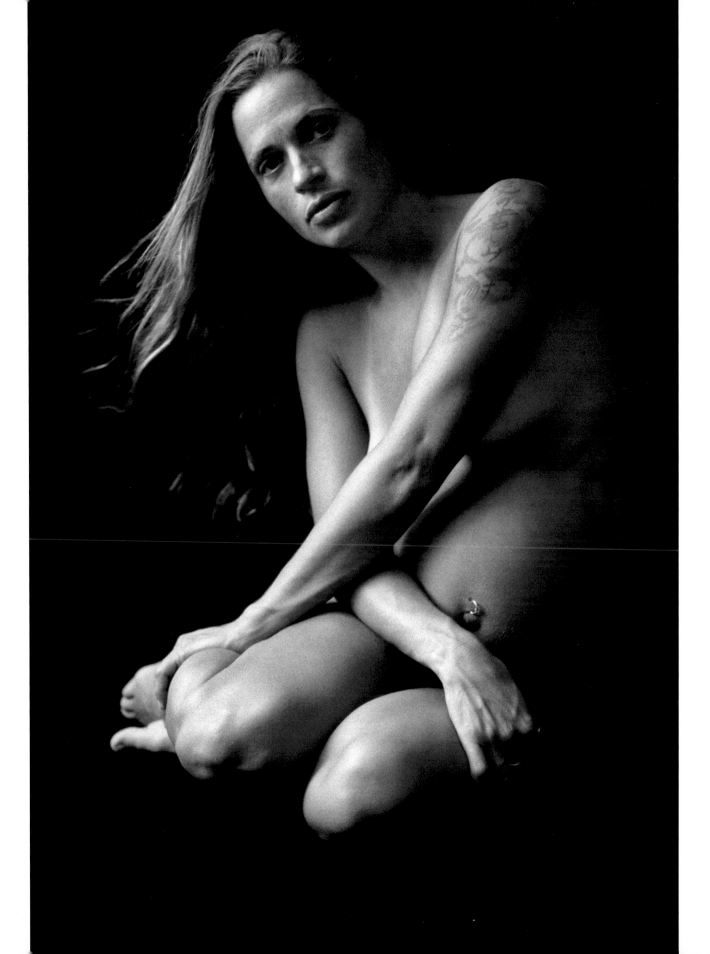

JENNA

IT HAS BEEN THE MOST WONDERFUL EXPERIENCE OF MY life to be so intimately involved in this part of God's creation—in the making of a new life. I have been humbled and awed through the gift of pregnancy and the daily blessing of parenting my four beautiful children.

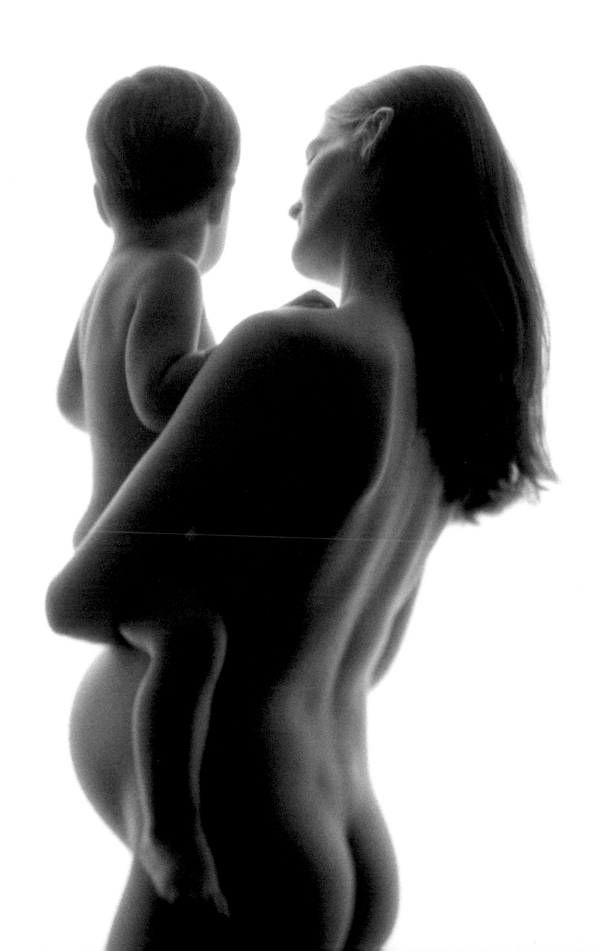

TELEVISION CORRESPONDENT KELLY WORKS FOR CBS NEWS IN NEW York, where she lives with her husband and daughters, Hattie Jane, two, and Lily Raya, eight months. Before she became a mother, she was a television news anchor, White House reporter, and foreign correspondent for CNN. The job was demanding, but the culmination of her dreams and ambitions—it was exciting and prestigious and took her to faraway and sometimes dangerous places. Just maintaining a relationship while working was a challenge, to say nothing of having a family. But Kelly had always wanted to have kids and in her late thirties, she and her husband finally decided to try to have children. But perhaps, she thought, she had waited too long.

KELLY

I WAS CONVINCED I WAS GOING TO BE JUST LIKE SO MANY WOMEN I KNEW WHO had problems getting pregnant. I was thirty-eight years old. I had a very stressful job.

In some ways I felt like I had it coming. I have always wanted to have children, but I had decided years earlier that my career would come first. I was all about my career for most of my twenties and thirties. It was a lot of stress and a lot of hours, but that was the decision I made. Whenever I was around small kids, it was obvious I was very much taken with them. I remember my colleagues teasing me, saying, "tick, tick, tick." But I never took it seriously.

I met my husband while I was at CNN. We dated for ten years, some of those years with each of us living in different cities. We finally got married when I was thirty-six, but we put off trying to get pregnant because I wanted to be married for a while before having kids. That, too, was a judgment I made. So if it turned out I couldn't have children, I thought that might be the cost of the choices I made. It was a horrible thought, but I had to accept the result of my decisions.

That's why I feel so incredibly lucky. After about six months of really trying—the year earlier we were sort of trying but it's tough to get pregnant while covering a presidential campaign—I got pregnant. When Hattie Jane was born, I was thirty-nine. I had a very clear plan for how the first year with my baby would go. I was completely wrong.

No one could have prepared me for how I was going to feel once I brought our baby home. I expected to have her, and three months later, on the dot, go back to work. I was

so surprised by the feelings of attachment I had, the incredible joy of being a mom. I remember thinking, "How on earth can I be away from her for twelve hours a day when I can't stand to be away from her for just one hour to get a haircut?" I never expected that. I was wired to be this working person, a professional, a correspondent. That's how I defined myself. Then I had my daughter and thought, "I love her so much, how can I ever go back to this other part of my life?"

What I learned is that you have to give yourself some time because after you have a baby you don't know how you're going to feel. Now, I look back and laugh at the certainty I felt when I was pregnant. I was certain that I'd go on maternity leave and after three months be back on the air as if nothing had changed. In fact, something incredible had happened. I ended up staying at home with Hattie Jane for eight months. I left CNN and found a job with CBS News that offered a more family-friendly lifestyle.

Still, I had to make compromises. On my fourth day at CBS, I got a call from the office. I was told I had to go to Boston on assignment for two days. I cried. I hadn't even left my baby overnight yet! I was convinced this working mom thing was never going to happen. My husband had to talk me off the ledge. I can laugh about it now. But at the time, the sense that my job was pulling me away from my child was powerful and scary.

And then about six weeks later, still new on the job at CBS, I learned I was pregnant again. I didn't expect to get pregnant so easily. I was sure it would take many months if it happened at all. Luckily, my bosses were very understanding. Still, I wondered how I was going to handle the demands of life as a network correspondent while caring for not just one, but two little ones.

After my second daughter, Lily Raya, was born, I stayed home for a little more than two months. I didn't have the same issues about work with my second child. I knew that I could work and not feel any less of a mom. I knew that my daughter was not going to love my babysitter more than me. The year I spent taking care of my first daughter gave me a better sense of what my needs were.

I don't think I'd be as good a mother had I stayed at home permanently. I have

I had a very clear plan for how the first year with my baby would go. I was completely wrong. No one could have prepared me for how I was going to feel once I brought our baby home.

tremendous respect for any mother no matter what choice she makes. At the height of my career, I don't think I understood why a mother would want to stay at home full-time with her kids. I see it completely differently now, and I would never make that judgment.

My priorities are my family and doing good work. That means I'm not likely to stop being a correspondent, even if I have more kids. But that also means I can't run out the door and be on the road for three weeks chasing a story. Before I had children, I would have been on the road covering the big campaign. I lived for that. But now, I'd be pretty unhappy if weeks had gone by and I missed Lily sitting up for the first time or Hattie Jane singing her first song.

A friend of mine once gave me some really good advice about balancing motherhood and career. She told me to imagine myself on a sailboat. "Sometimes in life you have to tack more toward your family. Sometimes, you have to tack more toward work or life outside of your family. But no matter what, you're still on that boat." I like that image. Some days my life is about tacking more toward home. Other times when those family demands are not so present, I can tack more toward work. It's a wonderful piece of advice that makes me feel like I'm always moving forward.

Motherhood has made me feel more grounded as a woman. I'm not only defined as Kelly Wallace the correspondent. Motherhood trumps that. I feel this confidence in who I am, this new sense of purpose that drives every part of my life. I like myself better at this stage of my life. I'm more in touch with myself and my priorities. Professionally, it enhances me, gives me a different view of a story. I feel more creative. I'm more willing to take chances. I have more energy. I would have thought I'd have less energy. But when you're forced to operate on all cylinders, you perform at a better rate.

I remember during the first trimester of my first pregnancy, Hurricane Katrina hit. Normally, I would have been racing to get to that story. My doctor said she could not tell me not to go. But I knew it wouldn't be the smartest thing. I didn't go of course. But I won't lie, I was conflicted, and the assignment wasn't easy to pass up. But I've come to discover some things are just more important. And there will always be another big story.

MARY

I MET MARY THROUGH WORK IN 1998. I AM A PHYSICIAN'S assistant, and she is an occupational hand therapist. I was very impressed with how well she took care of my patients. She was so good about communicating to me what additional therapy she thought they needed or if she had another idea on how to help them. She is such a caring person. We were married in 2000 and had Emme less than two years later. The legendary pregnancy glow made her more beautiful to me than ever. Toward the last trimester, she always had a smile on her face. I don't know how to describe it. Then the same thing happened three years later when she was pregnant with our second daughter. Both times she had that same extra beauty, that same glow, and that beautiful smile.

—*Jeff, Mary's husband*

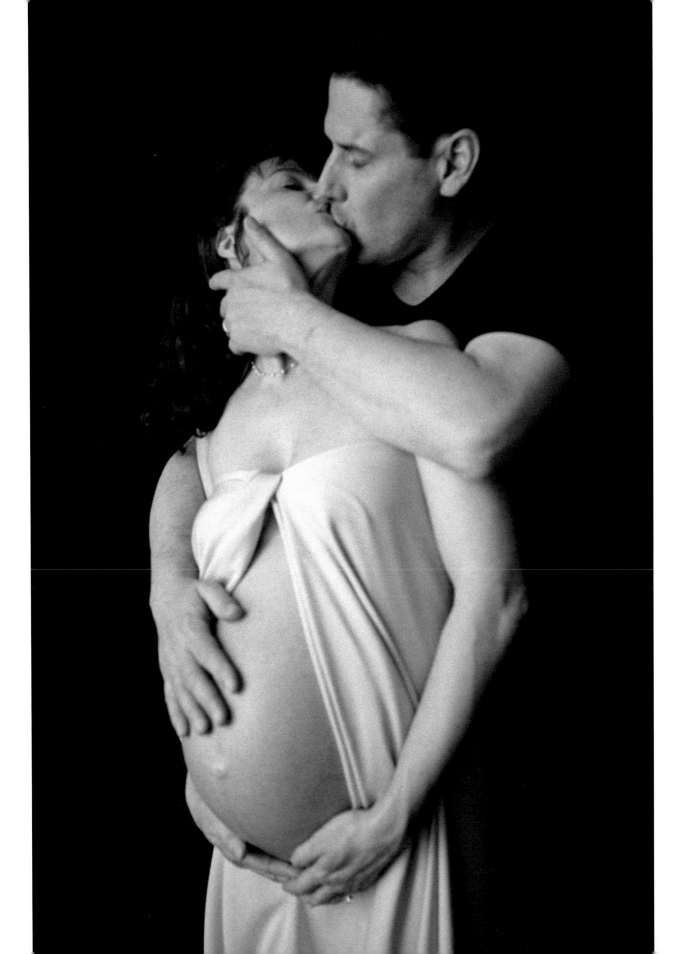

AMY

I HAD A GOOD PREGNANCY WITH AN EASY BIRTH. BUT EIGHT WEEKS after all the company left and it was just me and the baby home every day, I started sleeping all the time and crying. If I couldn't take a shower because the baby was crying, I would just start crying too. At the same time, I was having trouble breastfeeding, which made me feel like an inadequate mother. This horrible cycle developed, and I felt so over-whelmed. Even though we had a happy baby, everything seemed to make me feel worse. I just wished I could go into a deep sleep and never have to deal with life. Around the thirteenth week, I remember thinking I don't feel good, I don't feel right, my thoughts aren't good. I remember walking down the hill and wanting to let the stroller go so it would just go down the hill and disappear. I didn't want anything bad to happen to the baby; I just didn't want to be attached to the baby. That's what finally made me seek help from a doctor. The doctor identified immediately that I was experiencing postpartum depression. They put me on antidepressants and had me stop breastfeeding, which was a relief. I also connected with a support group of moms who were going through the same issues. I'm glad to say all that is behind me now. I can now see that it wasn't the baby; it wasn't me; it was the hormones in my body that were out of whack.

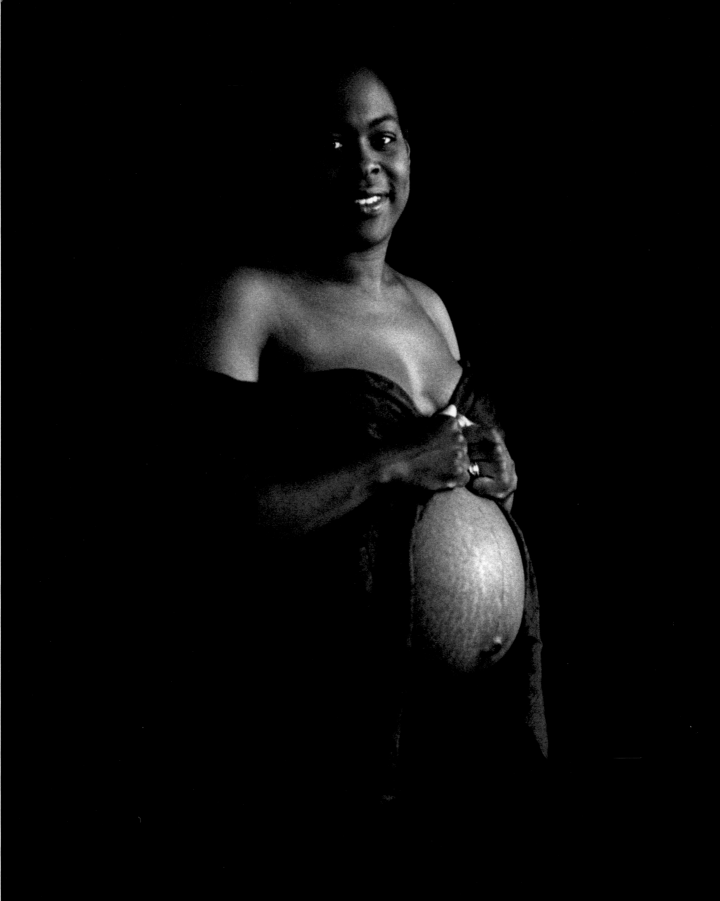

DARIA

Someone once told me, "You're not really married until you have children, and you don't really have children until you have three." This might sound a bit insulting to married folks without kids, or parents who have just one really challenging kid, but I have experienced the truth of this. Mark and I never knew how much we loved each other until we had children, and we never knew how much our love for each other would be challenged by the chaos, the sleeplessness, the all-consuming nature of parenting. Yet, with each child, I have only fallen more deeply in love with my husband. All of the superficial stuff about the other person burns away, and his essence, his true character shines through.

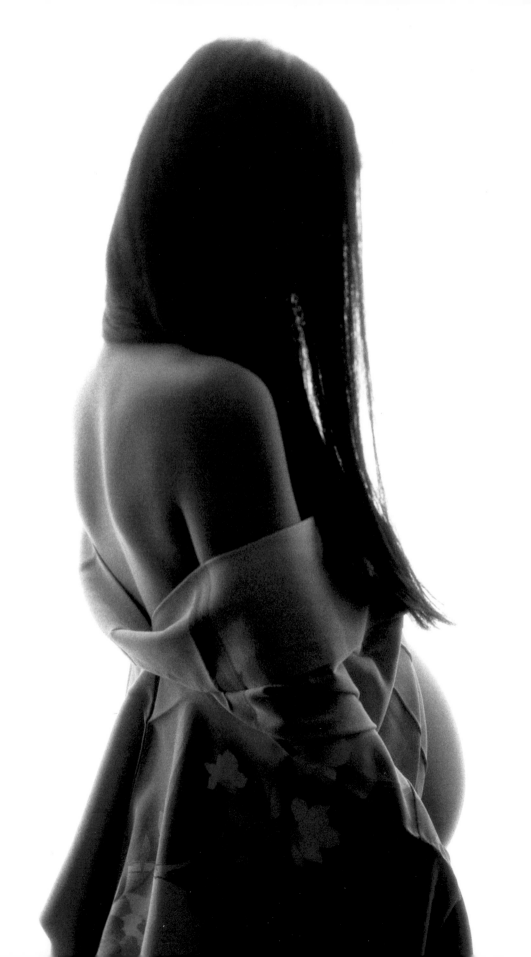

IZUMI

THE KIMONO I AM WEARING WAS GIVEN TO ME BY MY mother when I was married. I guess, in the old days, ladies in kimonos were not supposed to expose their expecting bellies in this manner. Here I am in the traditional kimono, releasing my belly in the light, fully embracing womanhood. Two things you don't see here are the little kicks I felt from inside and the loving presence of my husband, who was watching me from behind.

PREGNANCY WAS NOT AN EASY PROPOSITION FOR ODETTA. AS SOME-
one who recovered from an eating disorder at a young age, she ate carefully,
monitoring not just what she ate, but when and how she ate. All that ended
when she became pregnant. The pregnancy tested her ability to cope with
issues of weight and body image. Even as she rejoiced in motherhood and the
arrival of her two children, Owen and Parker, she struggled with the physical
toll the pregnancy took. Along the way, she learned to trust her body instead
of fighting it.

ODETTA

I HAD ALWAYS HOPED TO BE ONE OF THOSE PREGNANT WOMEN WHO CARRIED
tiny and compact. I thought I would have this tiny little ball for a belly
and it would be very cute. I wanted to be one of those adorable pregnant
women who were so tiny you could hardly tell they were pregnant—as if being able to
tell you're pregnant is a negative.

Of course I was just the opposite. I carried way big. I was so big people thought I was
having twins. In my second pregnancy, you could tell I was pregnant within weeks. Unlike
a lot of women, I didn't love being pregnant. I had a lot of physical challenges, and I did
not feel a deep, spiritual connection to my unborn child.

The unpleasantness of my first pregnancy was a surprise, and I found that it seemed
kind of taboo to talk about it, as if I should be all glow-y and happy. I had friends who
were earth mommas and hippy mommas who had these positive and profound experi-
ences being pregnant. I was looking forward to having one of those experiences too, but
it didn't happen for me.

Every time I lifted my leg, every time I took a step, I was in incredible pain. Ordinary
things like going to the grocery store were painful. I remember getting stopped at Whole
Foods, looking very much like the stereotype of a waddling, pregnant woman. I was try-
ing hard to wear cute clothes and feel girly. This woman stopped me and said, "I'm a yoga
instructor and I've noticed your hips are unbalanced."

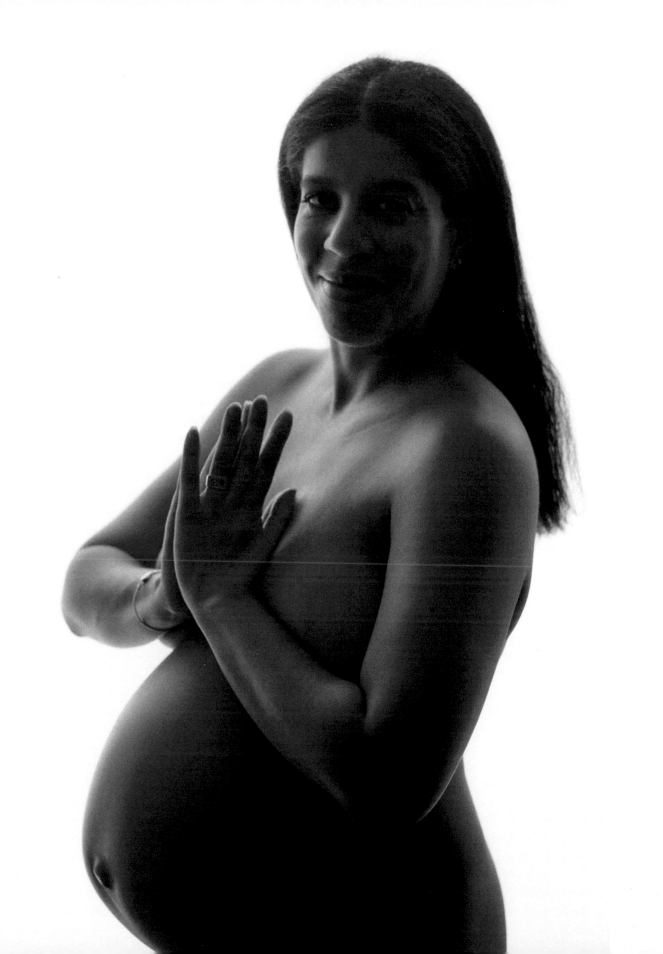

I realized that when you're pregnant, you become public property. People feel free to say things to you they wouldn't say to anyone else. I responded with something surly. The poor lady—she was just trying to help.

When I became pregnant for the second time, with my daughter, I was forty. I felt very blessed. My son was healthy, and now I was going to have a boy and a girl. For someone my age, that was true abundance. I was very aware I was never going to be in that position again.

Maybe because of that, I was able to manage the pain a little bit better the second time. But it was still very uncomfortable for me. Don't get me wrong, I'm so grateful and appreciative for that experience. But I can say I don't ever want to be pregnant again. I don't miss it. I don't pine for it.

But on the other hand, if you told me I could have the same children I have without ever having been pregnant, I wouldn't do it. As much as I disliked the experience, it taught me things that I am grateful I learned. I really got to trust and know my body in a different way. I saw my body's limits and how much it could handle. When I thought I physically couldn't do any more, my body did more.

It wasn't all bad. There was a sensuality about being pregnant the second time that wasn't there the first time. I was able to appreciate the roundness, the loveliness. I enjoyed not being able to see my toes. I definitely surrendered to it more, and once I surrendered I was able to recognize the beauty in it. I still didn't like it, but I appreciated it more.

Someday I hope to share with my daughter the stories and pictures of my experience of being pregnant with her. I hope it can be a launching point for her to express her feelings about her own body. Maybe her body will go through something similar. Having your mother's physical history is super important. It's a legacy I want to leave her, and these photographs will help set the framework for that legacy.

What I think I've learned is that I have no control over what my body does and that I don't want any. I suppose if I had millions of dollars, I could go under the knife and make it look the way I wanted, but that's not really control. I learned to trust my body. It knows what it's doing. It changed a lot and then changed back again. Everything is temporary. I might have had a certain kind of body before I was pregnant, but I'll never have that body again.

I know my body won't stay the same, and I'm not afraid of that. I no longer feel I have to do anything about it. Sure, I might try a little camouflage from time to time, but for the most part, my body knows what to do. It doesn't need me to manipulate it or to control it. It needs me to take care of it. It has its own wisdom. And what it needs me to do is to listen to that wisdom.

The unpleasantness of my first pregnancy was a surprise, and I found that it seemed kind of taboo to talk about it, as if I should be all glow-y and happy.

SUWI

WHEN I FOUND OUT I WAS PREGNANT, MY LIFE WAS COMPLETELY packed. I was studying acupuncture in one town while my partner worked in another town, a drive of over three hours. We had decided the soonest we could have a baby was one month after I finished my classes and could move to his city. Unexpectedly for us, our plan worked too well: I got pregnant immediately and my due date was exactly one month after I finished school. So during my pregnancy, I had all of these things that I had to complete and at the same time I was entering this huge transition. Carrying the baby helped put this hectic time into perspective. I had to do everything I had to do, but all of it seemed superficial relative to growing this baby and bonding with her. After spending so much time in a holistic health care environment, I was mindful to stay calm and positive through everything I had to do. I didn't want her to receive any negative emotions. I wanted to be present and welcome each moment, because I knew it was fleeting. I didn't want this special time to pass me by.

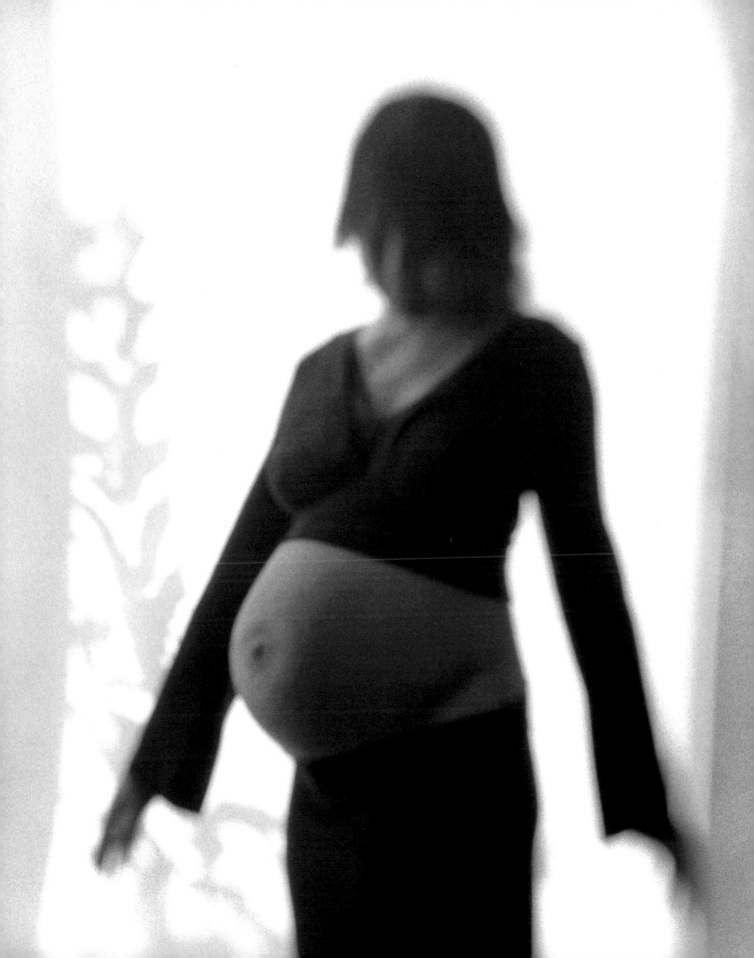

JENNIFER

I WENT FROM BEING A NEW YORK SEX AND THE CITY GIRL to being a San Francisco mom in about four months. The hardest part about being pregnant in a new city was not knowing anyone and having no support. Once I became a mom, an entire community opened up to me. What surprised me the most was that I became a mom to all children. When I was single and childless, a crying baby annoyed me. Now, I immediately feel sympathy for the parent and the child. Becoming a mom opened my eyes to how connected we all are and how we go through similar experiences.

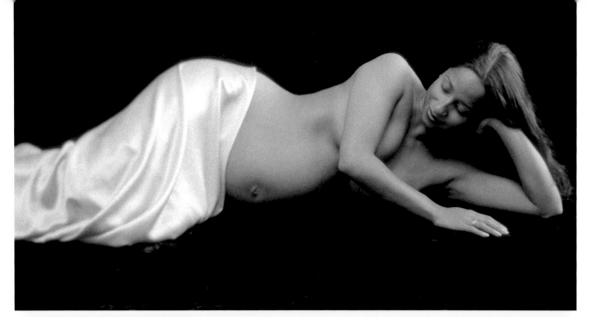

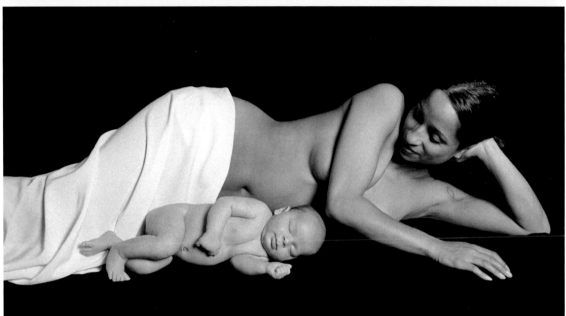

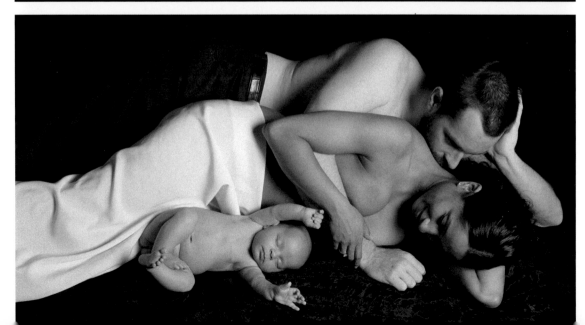

41

JESSICA

MY HUSBAND AND I DECIDED TO INVOLVE OUR DAUGHTER, Nyla, throughout the entire pregnancy. We valued Nyla's opinion as a part of our family so we asked her what she thought about us bringing a new member into the family. She said she was excited at the prospect of a baby brother or sister and came to all of the midwife appointments. Our son, Elijah, was born at home with big sister watching intently.

We have always tried to honor all of Nyla's feelings. Some days she doesn't like Elijah, but at the same time she loves him deeply. She hit her breaking point when he was six months old and asked, "When is he going to go away?" I said, "He's not." She cried a lot. I said, "I am sorry. It is OK to be angry, sad, confused, and happy. Those feelings are part of being a big sister, and they are all important."

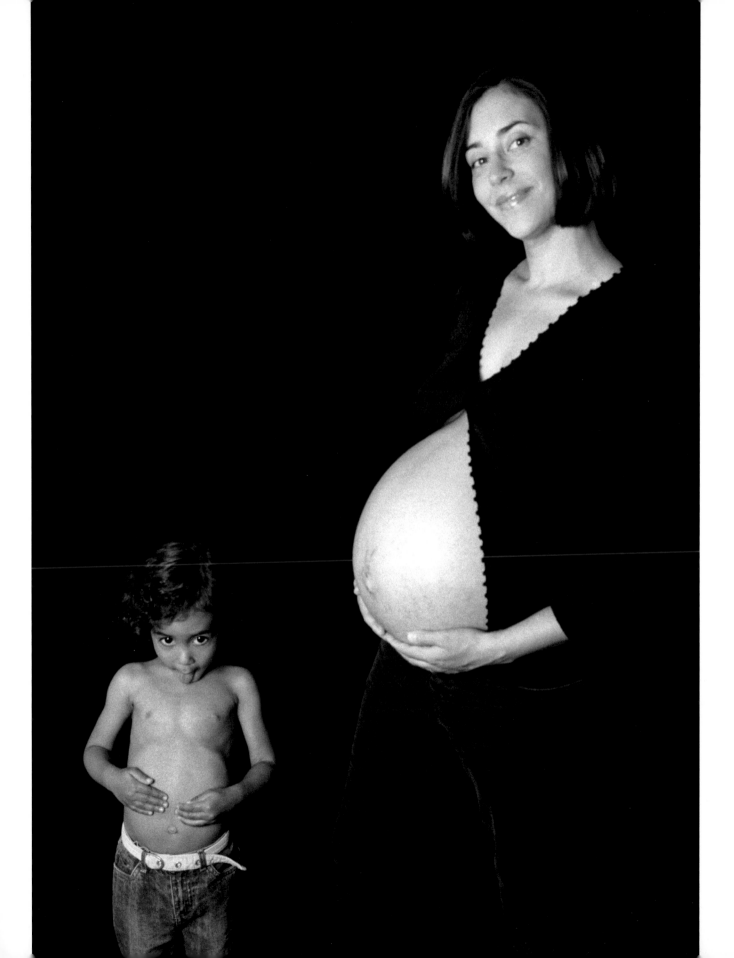

LIKE MANY YOUNG WOMEN, SARAH THOUGHT THAT ONE DAY SHE'D get married and have two children—with some luck a boy and a girl. And when that didn't happen, like many young women, she heard the same reassurances, "The right guy will come along," or "Don't worry, it will happen when you least expect it." Headstrong, self-employed, living in a loft in Brooklyn, Sarah took matters into her own hands. At age thirty-six, she chose to be a single mother. She didn't want to use an anonymous donor, and instead chose a former boyfriend who was still a good friend. The two of them planned the pregnancy carefully, writing down their intentions in a contract. Within a year, Stella was born.

SARAH

I'VE LED MY LIFE WITH A LOT OF INDEPENDENCE. FOR INSTANCE, WITH THE exception of a few years right after college, I've always worked for myself. The theme of my life is to be very intentional and thoughtful about choices. This was also the case when it came to having children. My preference, of course, was to have children with a man I loved and was committed to. Emotionally and financially, that made the most sense. But shortly before I turned thirty-five, with my biological clock ticking, I found myself having to consider other options.

At that point, I was not dating anyone seriously. So I decided to be very deliberate about creating a family. I signed up with an online dating website and at the same time I joined a group called Single Mothers by Choice. At first it felt like I was working at cross-purposes, dating while also pursuing pregnancy. But it was important to me to make a parallel investment in both goals—finding a partner and finding a way to have a child— even if one compromised the other. Of course I thought a lot about how having a child might affect my ability to find a good relationship. But I figured that a relationship can happen at any point in my life, but a child cannot.

At the very least, I wanted to know more about being a single mother, because for all I knew I would find out it wasn't for me. I never did find a relationship. But the more steps I took toward single motherhood, the more I realized this was something I could do. It felt like something I really wanted, not some desperate compromise.

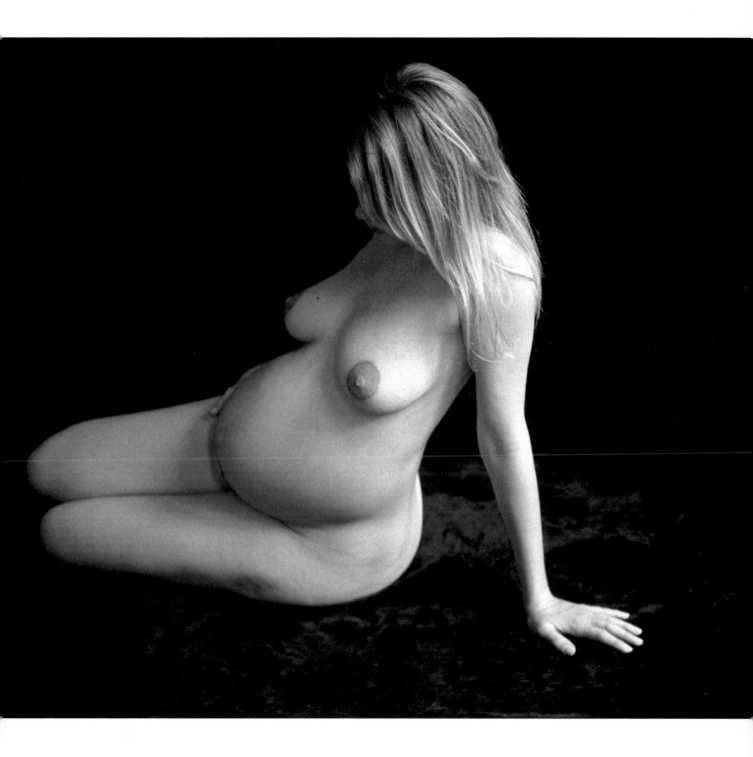

I feel incredibly proud of the mother
I've become. This was not the kind of
motherhood I imagined as a child.
But the more I think about it,
the kind of mother I am is also
the kind of person that I am.

My education in single motherhood involved a lot of counseling. I talked to my family about being a support system. I wanted to become a parent in a very mindful way. And the more I thought about it, the more it made sense.

Then, of course, I had to figure out exactly how I would get pregnant. I wasn't comfortable with the idea of using an unknown donor from a sperm bank. The first and the most obvious possibility for a donor was my friend John, who is gay. My discussions with John about becoming parents were lovely and comfortable. He seemed open to the idea and wanted to keep talking about it. But he also didn't seem as ready as I was.

About that same time I reconnected with a former boyfriend, someone I had been friends with for a long time before we even started dating. Our breakup was difficult, but we had managed to get our friendship back on track. During one of our conversations, he offered to be a donor. What made his offer appealing was the fact that I knew him well, both as a friend and a partner. We had been through all kinds of ups and downs and had survived them with grace.

Considering someone close to me presented more risks. What if he wanted more parental involvement than I wanted him to have? But because we knew each other so well, we both talked about it at length. We decided to write what we called an "intentions contract." It spelled out what we wanted and expected out of this arrangement. We imagined every possible scenario and described what we would do in each one.

People advised us to talk to a lawyer. But it would have been expensive to draw up a legal contract, and it might never even be upheld in court. The truth was that our arrangement would rely not on the law but in the trust we had in each other.

We tried to be honest and clear about our concerns, our questions, what we were sure about, and what we weren't so sure about. It was a caring process. There was no guarantee that everything would work out. You never know what's going to happen when emotions get involved. Emotions trump rational thinking. The process and the contract itself gave

The more steps I took toward
single motherhood, the more
I realized this was something
I could do. It felt like something
I really wanted, not some
desperate compromise.

us confidence that we could negotiate potential problems. The contract paved the way for my friend's involvement from that point forward. Today the situation looks pretty much the way we expected it to years ago when we first wrote the contract.

About three months after Stella was born, I moved to the Midwest, where my parents and grandmother live. The contract provided for this possibility. And so far, it's gone very smoothly. Stella's father has come to visit many times. At the moment, we're both happy with his level of involvement.

I feel incredibly proud of the mother I've become. This was not the kind of motherhood I imagined as a child. But the more I think about it, the kind of mother I am is also the kind of person that I am.

Before I became a mother, I had always felt like there was something I still needed to learn to be in a successful relationship. Now I feel like I am learning through my relationship with my daughter and through my connection with her father. He and I have to be thoughtful and mindful for things to work between us. In the past, if something was too challenging, I was out of there. Now I don't have that choice, and consequently, I've learned how to nurture my connections and achieve the depth that I had been missing.

Stella's father is an amazing man, and I hope she has all his fabulous qualities. Right now, his involvement is limited. I do not yet know what would happen if Stella wanted more of a relationship with her father. I want her to have as many deep connections to people as she wants to, and I'll do everything I can to encourage it.

The irony is that when I was dating Stella's father, we broke up because I wanted the relationship to go to the next level and he was not ready. And then years later we ended up intentionally having a child together. But we made that choice together as opposed to me imposing that choice on him. It's a more rational, conscious approach that is harmonious and loving, and hopefully it represents the sort of mindfulness my daughter will use to make her life choices.

BINA

*A*LL THREE OF MY PREGNANCIES WERE NOT NORMAL. I HAD A CONDITION called hyperemesis gravidarum. It is a rare disorder characterized by severe and persistent nausea and vomiting during pregnancy that may necessitate hospitalization due to severe dehydration, vitamin and mineral deficiency, and loss of weight. This prolonged and debilitating condition, which challenges you mentally and physically, is so severe that many pregnancies are terminated. I had experienced all of these symptoms with all three pregnancies, but the last pregnancy was the worst. I had a PICC line placed in me and was attached to an IV pole for hydration and nutrition for one month. I was also hospitalized during all three pregnancies for severe dehydration and lack of electrolyte balance, and the doctor feared that I may get arrhythmia in addition with the last one.

I knew if I could sustain the pregnancy, there would be light at the end of the tunnel. That is what kept me going until the symptoms slowly subsided after four months. For the remainder of the pregnancy I continued to regain the nutrients and weight that I had lost. Many women struggle unsuccessfully to get pregnant. I felt my struggle was just to maintain the pregnancy to successfully have a baby. So when I look back at my pregnancies, I don't immediately have that "warm and fuzzy" feeling, but a feeling of survival.

When I see this picture of myself looking at the girls' upturned faces, all the bad memories of the pregnancies vanish. I am overcome with an inexpressible joy and the feeling of unconditional love. Without a second thought, I would go through the struggles again to have my three beautiful girls that I am lucky to have today. One should never take pregnancy for granted. Babies are gifts from God, and mothers are the beautiful messengers of God who bear the gifts that are the true miracles of life.

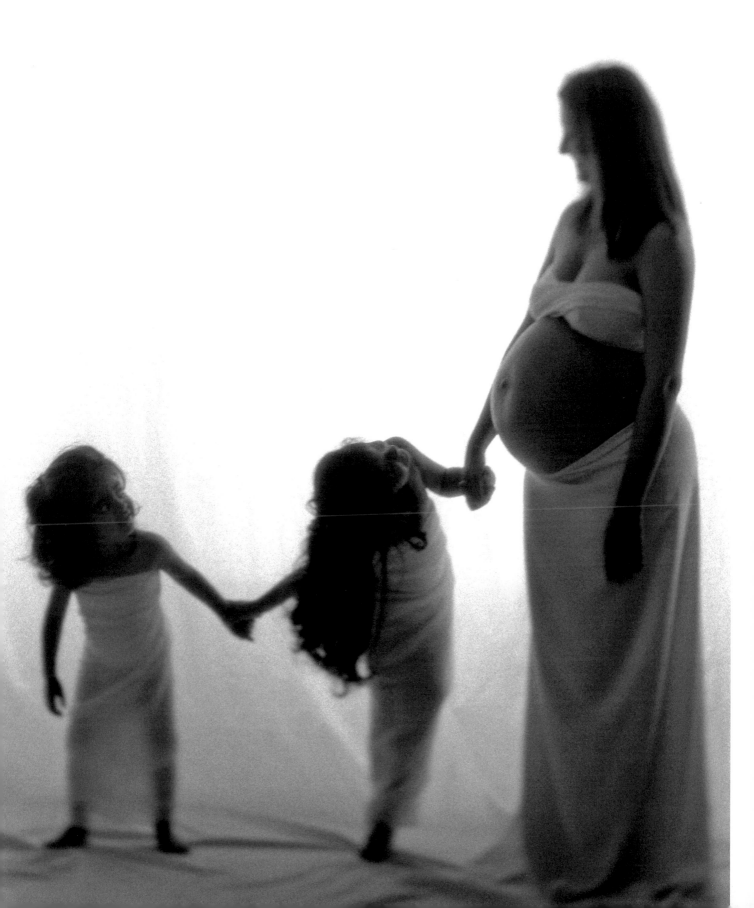

TONYA

OUR LIVES HAVE ALWAYS BEEN FILLED WITH A LOT OF excitement and adventure, and this pregnancy was our next great journey. This was our first baby, and the pregnancy was such a joyous and celebratory time for us. We loved all the beautiful changes in my body and had so much fun and so many good laughs talking about all the newness and unfamiliar experiences ahead.

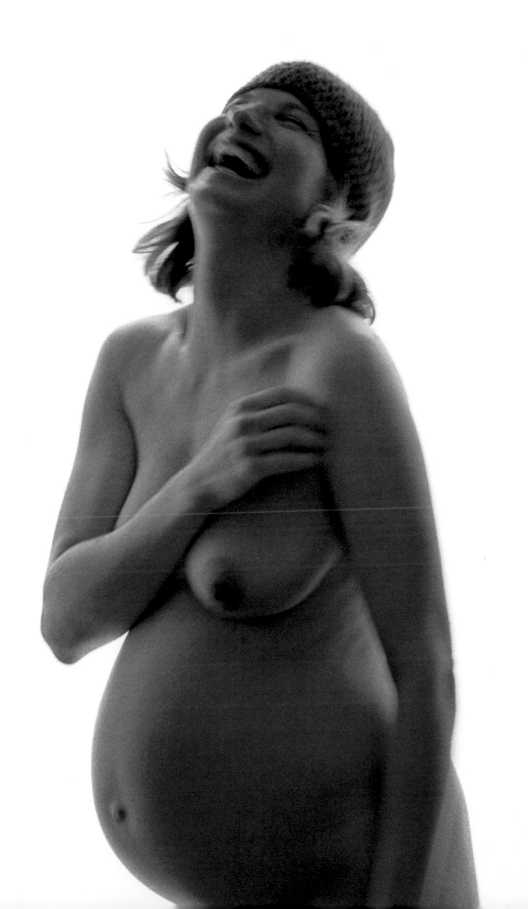

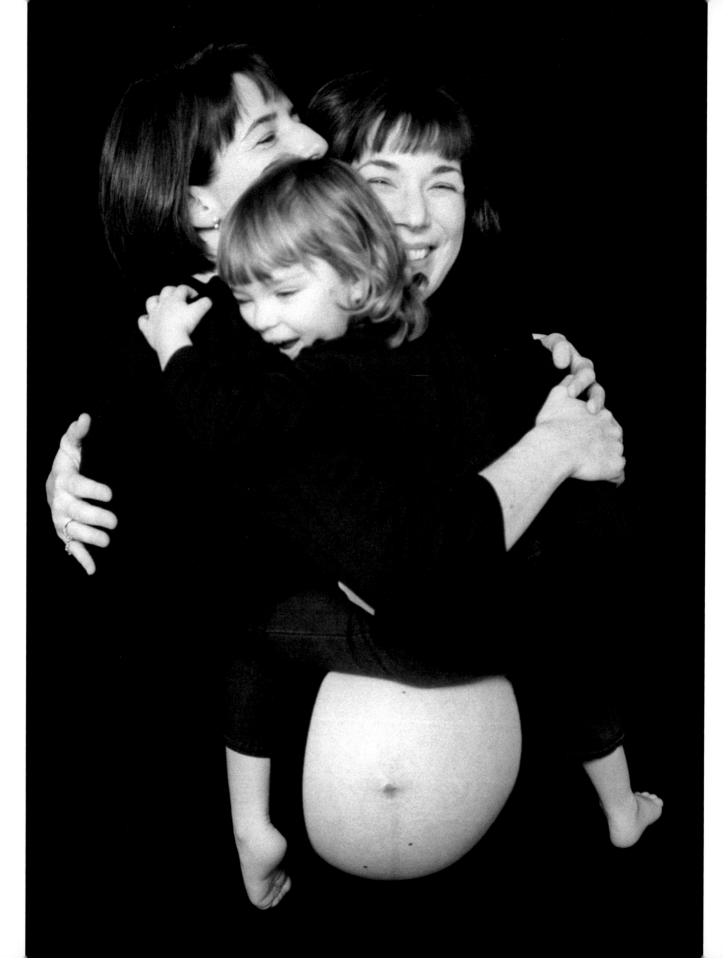

RENELLE

URING MY PREGNANCY, I WORRIED ABOUT GAINING enough weight to support twins. I stopped exercising and really tried to focus on taking care of the babies and myself. I also worried about not getting enough time with my eldest daughter. I was always so tired. When I was put on eight weeks of bed rest before the twins were born, I felt like the rug had been pulled out from under my daughter and me. To help everyone with the addition of the twins to our family, we hired a nanny while I was still on maternity leave. The nanny stayed home with the twins, and I was able to spend one-on-one time with my daughter.

DANVO'NIQUE

THE MOMENT I FOUND OUT I WAS WITH CHILD, I CALLED my husband to share the wonderful news. He said he knew all along that I was pregnant because that morning he had been craving pancakes, which is something he rarely eats. He said he felt it that morning before I went to the doctor. He has always been in total synch with me. He even knew I was going to have two boys and one girl, in that order. We are very spiritual, and we pray every day. Thank you, Jesus. Thank you, Jesus. This is what I say every day, and what I said when I had these photos taken when looking upward. We have been so blessed. I thank Jesus so much for my family.

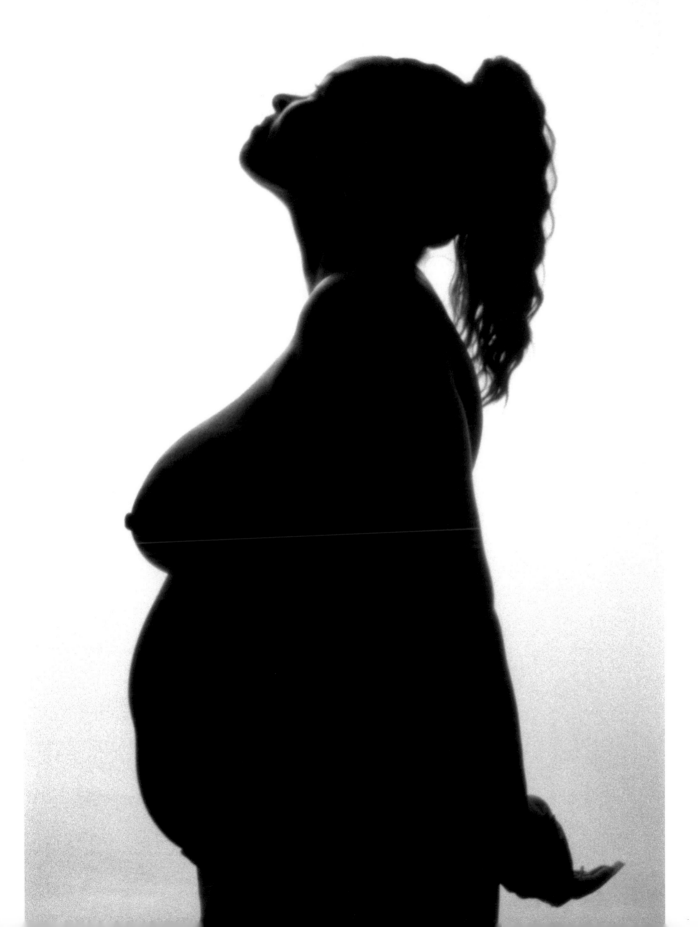

GRACE MARRIED AT AGE EIGHTEEN AND WAS TWENTY-SIX WHEN HER daughter, Khloe, was born. Compared to most of the women she knew growing up, she was relatively old to be a mom for the first time. But Grace had different ideas for her life and her daughter. Grace felt that the women she grew up around made poor and destructive choices in their lives. She did not want to commit the mistakes she saw others make. Creating a better life for her daughter meant creating a better life for herself first.

GRACE

OST OF THE PEOPLE WE KNEW HAD KIDS BEFORE GETTING OUT OF HIGH school. No one really understood why we waited so long. A month after high school, my husband and I eloped. Most people thought we got married because I was pregnant. All we knew was that we wanted to be with each other all the time. And we wanted to enjoy our newfound freedom.

At first, we both worked in restaurants. We didn't really have a plan. In retrospect, we were naïve about how different life would be once we lived together and about the financial hardship we would face as a young couple. But we had each other and were determined to do whatever it took to make the marriage a success.

We graduated from restaurant jobs to office jobs, working 9:00 to 5:00. Eventually, we began to live comfortably. We took vacations and ate out, did what we wanted to do, focused on ourselves.

In our Mexican-American culture, having children right away was the natural step for most. But we questioned that logic. It did not seem fair to us to have a child just because you were supposed to. It was very difficult having to explain our reasons for waiting. To others it seemed like a selfish decision, but we knew that we were waiting for the right reasons. And they were far from selfish.

We knew that bettering ourselves first would have a direct impact on our children. We wanted a better life for our children. To us, that meant making mistakes before we had children, not after. We did not want them to suffer while we got our act together. Today, our daughter has no idea what it means to not have her own bedroom, or not have money

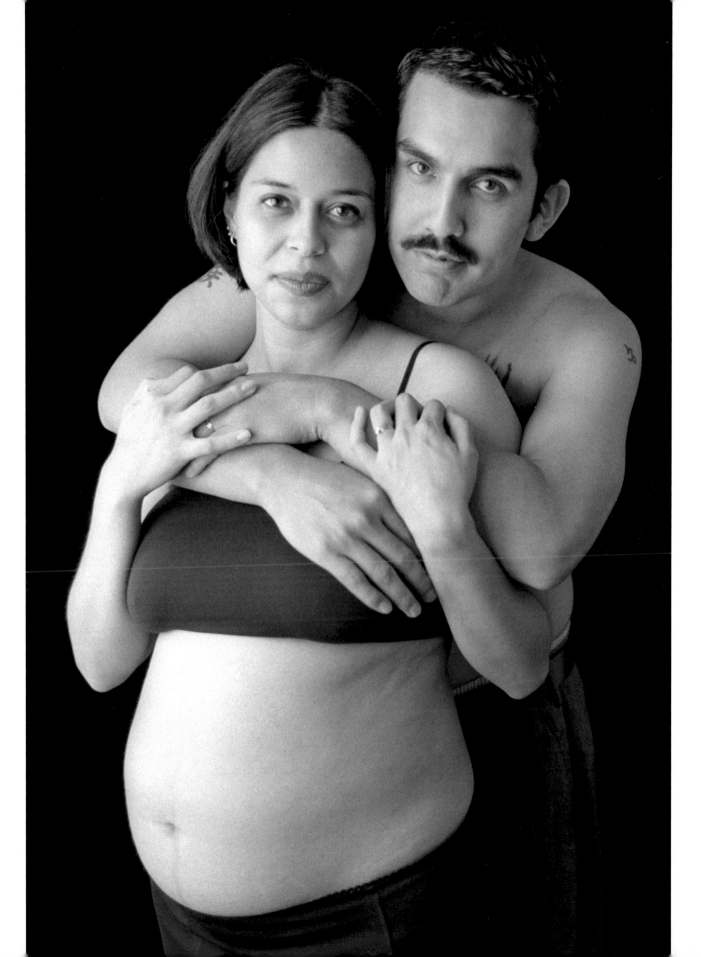

to buy clothes, or not have one of us there for her whenever she needs us. I wanted to be mature enough to take care of someone other than myself. Most of all, I wanted to know in my heart that I would not repeat the mistakes of my own mother.

I grew up surrounded by lies. I endured physical, sexual, and emotional abuse. At the time, my mother told me that "it happens to everyone." I will never forget those words. I've turned those words around. Now, I say, "It will not happen to my daughter." I use my mother's lack of strength as motivation to make better decisions. I want Khloe to always remember the way I love her. I am probably heavily overcompensating, but I don't want to slack off. The moment I do, I might regret it for the rest of my life.

I could have easily repeated my mother's mistakes. I could have consumed myself with my husband and my job and neglected my child. I could have raised her while not really knowing her. Or worse, I could have left her susceptible to danger.

My mother told me she was doing the right thing by having a father figure in my life and by staying with him. But it cost me my childhood. I saw that abuse was to be expected, that infidelity was a part of life, and that most women had little power in their marriages. I cannot be my mother.

I have found a man who cares for me regardless of my flaws and empowers me to be a better person. In turn, I try to do the same for him. This mutual desire to succeed as a family is something I doubt my mother ever knew or will ever understand.

Our daughter is the center of our lives. Today, my mother constantly tells me what a good mom I am. I lack the courage to tell her that, ironically, it is because of her.

Before having Khloe, we started a pet-sitting business because we wanted to find something flexible, something that allowed us to spend time together as a family during the day, and at the same time do something we loved. At the age of twenty-five, I decided to get my college degree. My husband went to college too. Later I got my master's in business administration.

We wanted a better life for our children. To us, that meant making mistakes before we had children, not after. We did not want them to suffer while we got our act together.

I was always thinking about what kind of example we were setting for our daughter. We wanted it to seem normal for her to go to college. We wanted her to feel this is just what you're supposed to do. We had to figure it out as adults. So while she was a newborn, I was still taking classes.

I think in everything we do now in some way we are trying to set an example for Khloe. When I was younger, I never played any organized sports. After I had her, I was looking for a way to lose the pregnancy weight so I started to play soccer. Now I play all the time. And so does Khloe. Her father coaches her team. I also recently ran a marathon with my husband. I want it to seem normal and natural for her to have the opportunity to excel at anything she does.

Khloe takes swimming classes, is in the Girl Scouts, and is learning tae kwon do. Everyone always tells us how busy she is. We also volunteer at her school. My mother never knew how I was doing at school, and I remember feeling embarrassed and alone; I thought she simply did not care. Growing up, I wish I had been more involved in sports. I wish I had been more active in school. I believe it is more difficult to want to excel if you do not have a role model. I regret so many things.

What was uncomfortable for me, I want to be natural for Khloe. We will support her in whatever she wants to do, so she won't hesitate to venture past her comfort zone. I can't do anything about my past. But the vicious cycle can and has to end with me.

The family business also gives us time to work on other things in our spare time. My husband works on achieving his personal fitness goals. I write. One of my ambitions is to write a children's book, maybe about a princess, one that girls like Khloe can relate to. I started it a year ago. I haven't finished yet. I don't know if I'll actually publish it. Maybe it will be only for Khloe to read. That would be fine. Because she's the one I'm writing it for.

DANIELLE

ROWING UP I HAD ALWAYS WANTED TO SEE WHAT MY mother looked like when she was pregnant with me, but, since it wasn't common then to celebrate pregnancies like we do now, there weren't any photos. I have photographed all three of my pregnancies so I can show my children how I looked pregnant with each of them.

Each pregnancy has been unique and special. We tried for nine months before I became pregnant with Aaron, my first son. As my first pregnancy, it was exciting because of all of the unknowns and first-time feelings associated with it. Then, after a miscarriage and six months of trying, there was the extra joy of finally being pregnant with Aidan, my second son. My last pregnancy with Andrew, my third, was a beautiful sweet surprise. He just came—we didn't try at all.

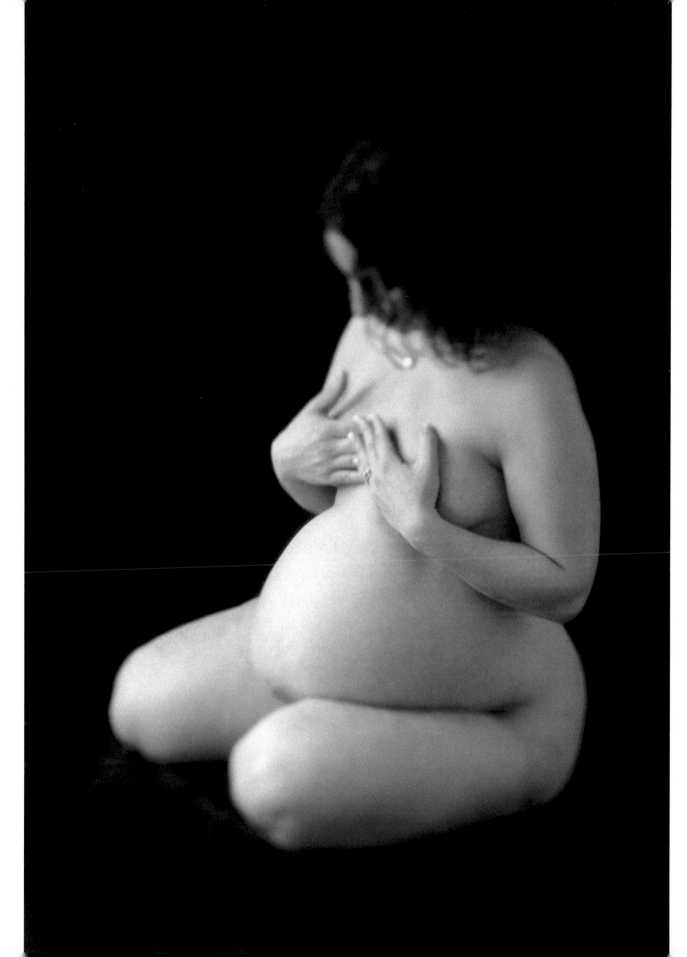

HEATHER

I WAS FIVE MONTHS PREGNANT WHEN MY RELATIONSHIP ended. I remember feeling contracted with an over-whelming sense of hopelessness. It was difficult to imagine how things were going to work out. As I look back on it, I realize that the opposite started to happen. My life began expanding as I became a mother. Doors opened. I met new people. I was pushed emotionally and drew upon inner strength that I didn't know I had. Now I have the courage and confidence to get through any-thing. I now believe it is possible to find that special person. I did and am living with my lifelong partner. I never imagined being so happy. I felt so alone before; now I am in a cohesive unit. We are a family. We have a strong, secure bond. Motherhood isn't the end-all but it always changes your life. It pushed me toward a happiness that I never dreamed I would find.

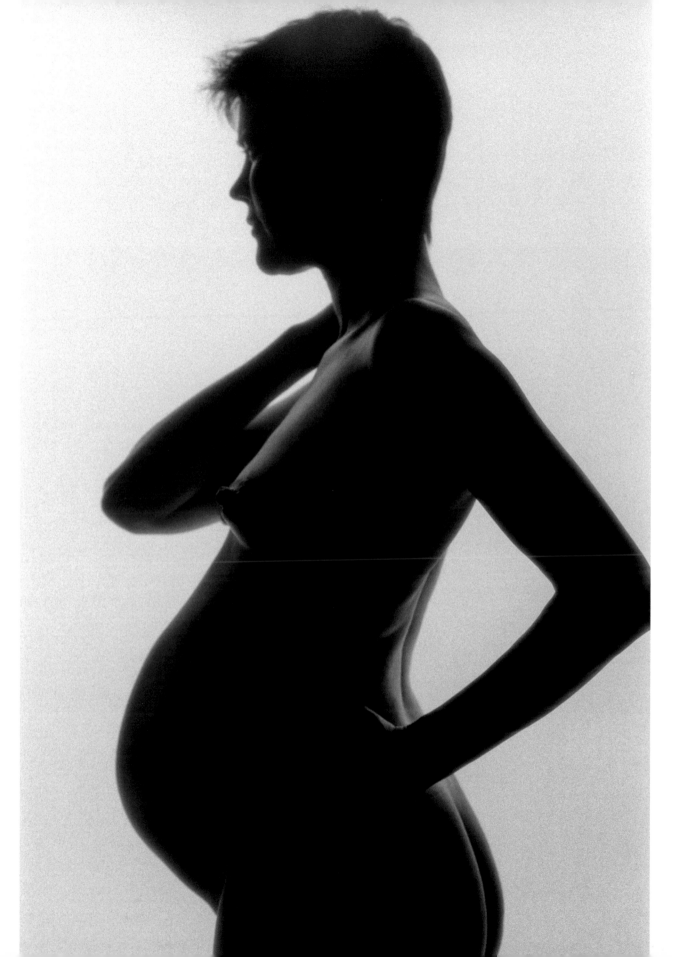

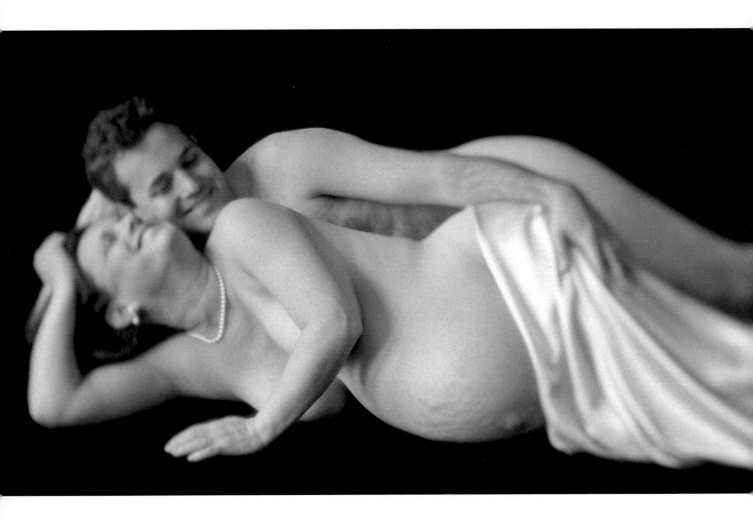

RACHEL

I WAS EXTREMELY ACTIVE UNTIL THE VERY END WITH BOTH of my pregnancies. Although I always planned to take the last two weeks off, I never did. With my first pregnancy, my water broke at temple but instead of going immediately to the hospital, I went home first to shave my legs. With this pregnancy I went to my doctors' office for a regularly scheduled appointment, and they discovered that I was already five centimeters dilated, which was a surprise for me. They sent me right to Labor and Delivery, and I had our twins that day.

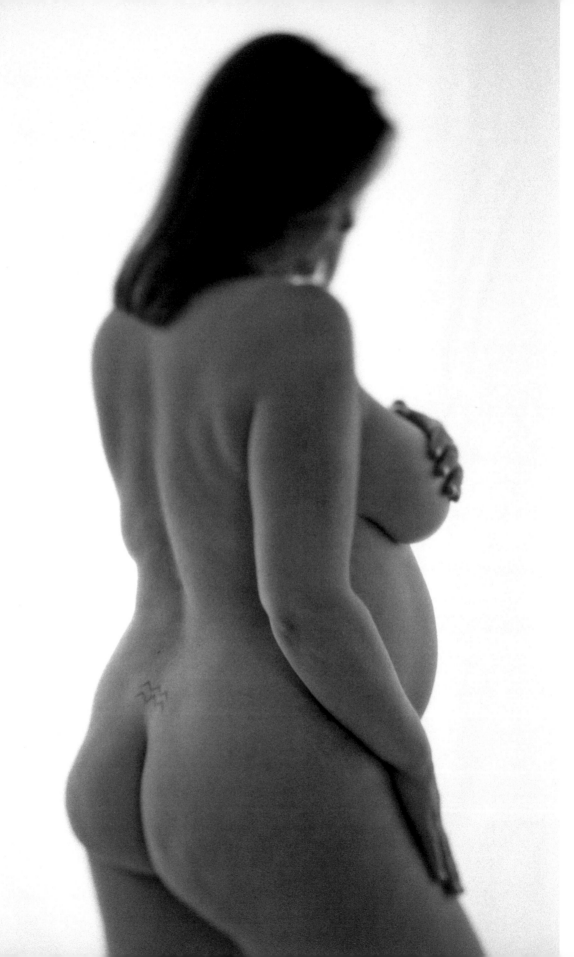

AS MANY AS HALF OF ALL PREGNANCIES END IN MISCARRIAGE. But as common as it is, that doesn't lessen the heartbreak it brings. Ariane miscarried not once, not twice, but five times before she gave birth to her son, Scout.

ARIANE

THE FIRST TIME I GOT PREGNANT, I WAS THIRTY-THREE, AND MY HUSBAND, JORDAN, and I had been married about a year. The great thing about finding out I was pregnant was that my sister, who was twenty-seven at the time, was also having a baby. Our due dates were just nine days apart. We both lived in San Francisco and were best friends. I couldn't imagine anything better than experiencing our pregnancies together.

My sister tends to worry more than I do, and ironically, she told me she was concerned she might have a miscarriage. I reassured her again and again that she had no medical reason to worry. I never thought that I would be the one to have a miscarriage instead.

It happened during the first ultrasound appointment. Our doctor told us there was no heartbeat. My husband and I were in shock. We just kind of looked at each other. I went to that appointment expecting to see my baby, and I left without one at all. I had to have a dilation and curettage performed at that same appointment.

It was a loss, but it didn't break us down. It just made us want to try again. I'm an optimist and believe every setback is a lesson learned in disguise. Every visit to the doctor showed I was healthy. I talked a lot about the miscarriage with my mom, my sister, and my husband. I even ended up telling strangers sometimes. I'm glad I did, because I found out just how many women have had miscarriages. I had no idea.

The second miscarriage felt like being run over by a truck because this time we had gotten to see the baby in an ultrasound image. And we had heard the heartbeat. Then two weeks later, the baby had no heartbeat.

In the meantime, my sister had a baby girl. When my little niece was born, it reminded me she was supposed to have a cousin born nine days later. Thinking about it was hard, but I was so happy for my sister. I didn't want to hate her or any other mother because I wasn't one yet. Plenty of other people have challenges too, whether it's diabetes or cancer. Mine happened to be pregnancy.

The getting pregnant part never seemed to be a problem. It always happened easily and quickly. I stopped sharing the news with my family though. I didn't want to drag them along on this roller-coaster ride. Of course, when they found out they scolded me for not telling them. "What's family for?" they asked. "We don't want you to go through this alone."

After my third miscarriage, I started to see a fertility acupuncturist. At the same time, I did everything possible to make sure I had a good pregnancy. I ate right, took care of myself. I consulted a homeopathic therapist who specialized in miscarriages. But again, for the fourth time, I miscarried.

I decided to go see a high-risk pregnancy specialist, someone I knew through friends. And I also began to accept the reality that I may not ever be able to give birth. My husband and I looked into adoption. I've always been very supportive of adoption, and it was something we might have done anyway.

Meanwhile, I hung on to the hope that I could see a pregnancy all the way through to birth. My doctor put me through the wringer, testing nearly everything that could be tested. I was almost hoping to find a problem so at least I would have an answer. I remember thinking, "Please tell me I have a blocked fallopian tube so we can do in-vitro fertilization." But it turned out I was fine. Jordan and I continued to investigate adoption.

By then, I had a hard time getting attached to the idea of being pregnant. I didn't want to get excited or bond with my unborn baby. I was taking hormones and aspirin but was in disbelief that any of it would help. Despite the treatment, my fifth pregnancy ended in May 2007.

I talked a lot about the miscarriage
with my mom, my sister, and my husband.
I even ended up telling strangers sometimes.
I'm glad I did, because I found out
just how many women have had
miscarriages. I had no idea.

This time I knew the baby was a girl. Knowing made it even harder because it all seemed so real. Until then, I could make myself believe that none of the miscarriages involved actual babies. Emotionally that helped me. The fifth miscarriage was the one and only time I knew anything about the baby.

After all my trips to the doctor, it turns out the one thing we didn't test was my blood. It was the last thing we thought of. The next month, my husband and I went to see a reproductive immunologist for extensive testing. I learned that I had a few otherwise harmless blood conditions that frequently resulted in miscarriage. At last, the mystery began to lift.

I was supposed to begin receiving treatment in a month to offset the blood condition. To take my mind off things, my husband and I left on a trip. After every miscarriage, I would take time to be alone and grieve the loss. My husband and I would always do something fun between each pregnancy. We would drive to the wine country, fly to Mexico with friends, stay active.

But before I could even start the treatment, I inadvertently got pregnant for a sixth time. I was told that because I had not started the treatment in time, the chances of a successful pregnancy were reduced by a third.

I assumed I would have yet another miscarriage. But I still started treatment mid-pregnancy to give it every chance I could. During the sixth week of pregnancy, my worst fears were realized. I began to bleed profusely. I was tested the next day. The bleeding turned out to be a fluke. I was still pregnant.

It was a unique situation to go to the doctor's office and hear good news. For me, loss had become normal, but the miscarriages had become especially hard for my husband. We both struggled, but I had maintained a level of detachment that protected me. I also hung on to this fundamental faith that something was going to work for us.

Over the course of two years, I was pregnant, on average, every three months. It took

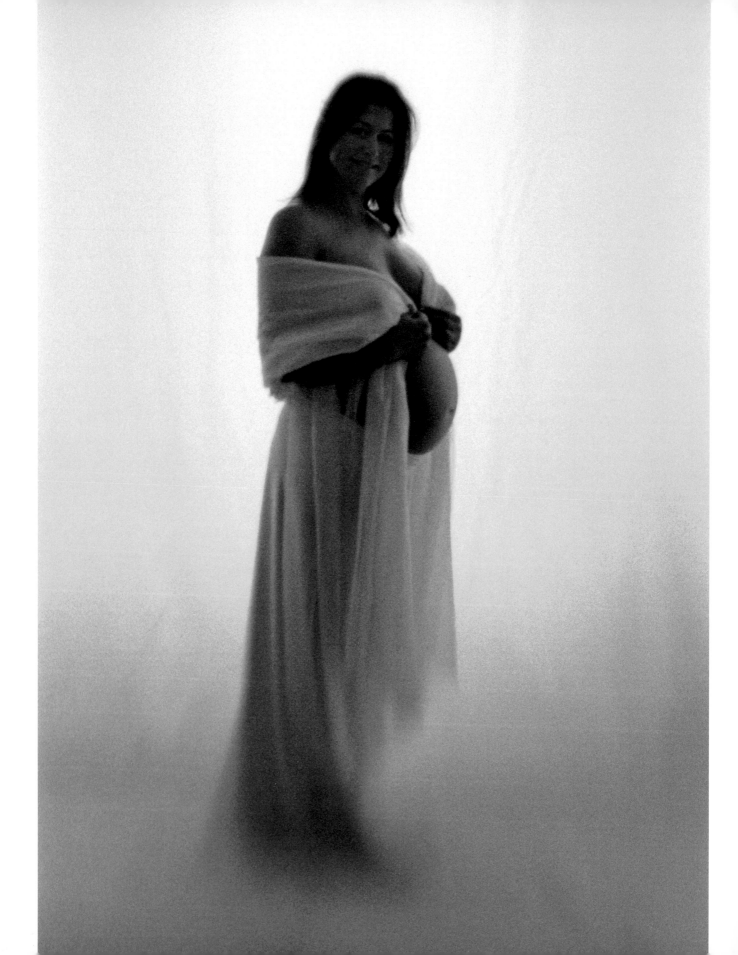

It was a unique situation to go to the doctor's office and hear good news. For me, loss had become normal, but the miscarriages had become especially hard for my husband.

a toll on my body. I gained five pounds each pregnancy. And because I was a high-risk patient, doctors told me not to exercise. I'm a control freak, and letting go of control was one of the biggest lessons I learned during those two years.

Throughout the sixth pregnancy, I kept waiting for the other shoe to drop. Yet, to my amazement, my stomach kept growing bigger and bigger. I remember the joy I felt when I was able to go shopping for maternity clothes for the first time.

One day I felt the baby kick. But there was still this feeling of detachment, because it was so hard for me to accept the reality that I could actually give birth. I chose not to learn the sex of the baby. I've always wanted it to be a surprise, the old-fashioned way. And with five miscarriages behind me, I definitely did not want to know.

We picked a name that we thought would work for either a boy or a girl. We chose Scout, based on the character from *To Kill a Mockingbird*. Jordan and I both read the book while I was pregnant. I was excited about picking a name, but also nervous. If I miscarried again, I felt we would have to have a funeral, because now our baby had a name.

There was a tremendous amount of anxiety. We had a few little scares. At week thirty, I started to show signs of premature labor. I went on full-time bed rest. Five weeks later, I gave birth. Scout arrived five weeks early. His name means "someone who can find paths through unexplored territory." Suddenly his name had even more meaning.

The first time I saw Scout's face, I felt like I recognized him. But I wasn't in love with him immediately. I'd like to say I was, but it took about a day. I think I was still trying to get over the feeling of detachment that helped me get through the miscarriages. But soon, I was completely obsessed. It just took me a while to realize he was my baby and that it actually worked. It had really happened.

Whatever comes in the future, Scout will always be that special baby. He's been healthy since the first day. He's my resilient baby. He endured all the shots, all the treatments. He's a survivor. He's the one that made it through.

BATHSHEEBA

 LOVE YOU

You have so many things no one else will ever have.

You have all my love now and forever.

You have my admiration for being such an incredible person.

You have my unending gratitude for the way you brighten my life.

You have empty pages in the story of your life, pages I would like us to write together, filling them with memories we will make and stories that will travel beside us and carry us over whatever comes along.

You have my sweet appreciation for taking my smile to places only my heart dreamed of and you will always have me.

I thank God for you and blessing me with my children.

I love you.

—Written to Bathsheeba while she was pregnant, from her husband, Drago, who was stationed with the navy in the Middle East

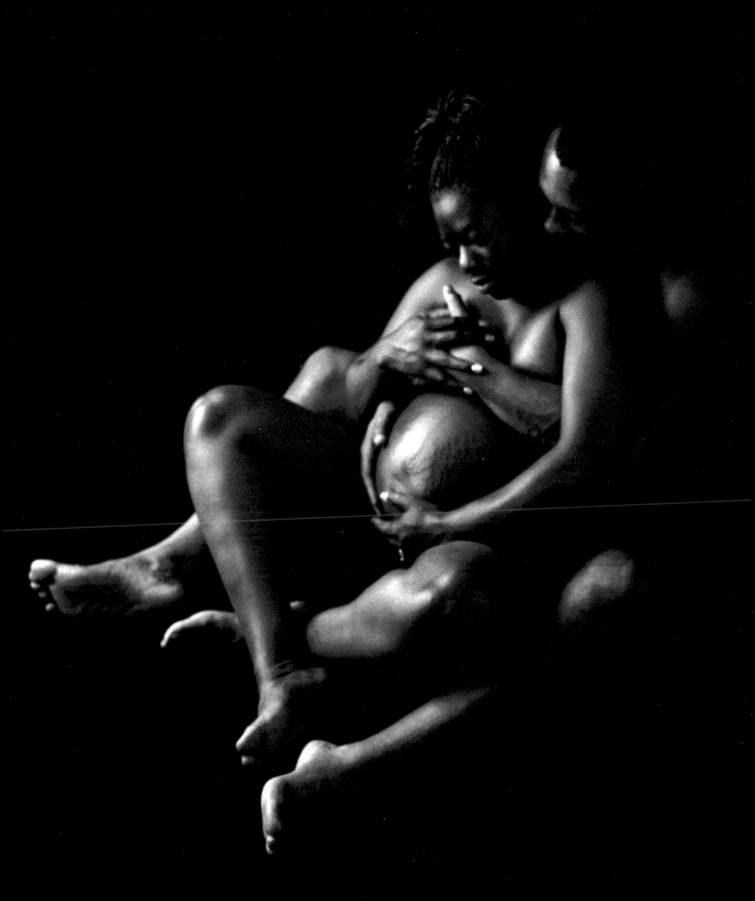

STACY

THIS WAS MY THIRD BABY, SO I WASN'T TOO SURPRISED BY anything with this pregnancy. Except that no matter what child this was, I knew I loved him. His older brothers loved him. His dad loved him. And the love we already had for our older boys didn't diminish at all. You can't divide love . . . it multiplies.

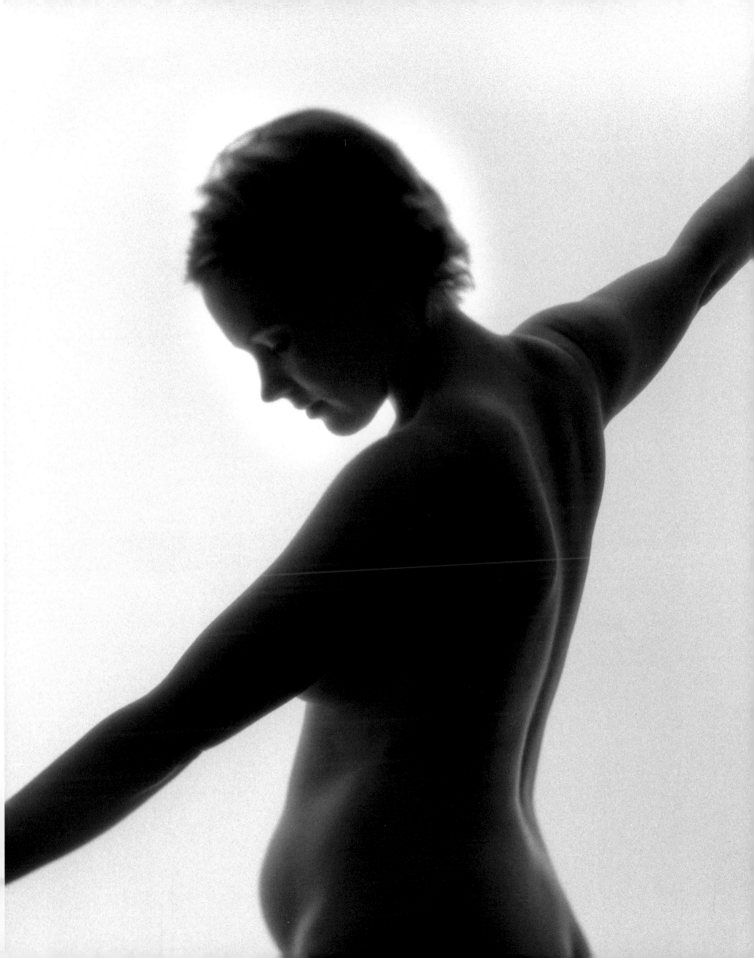

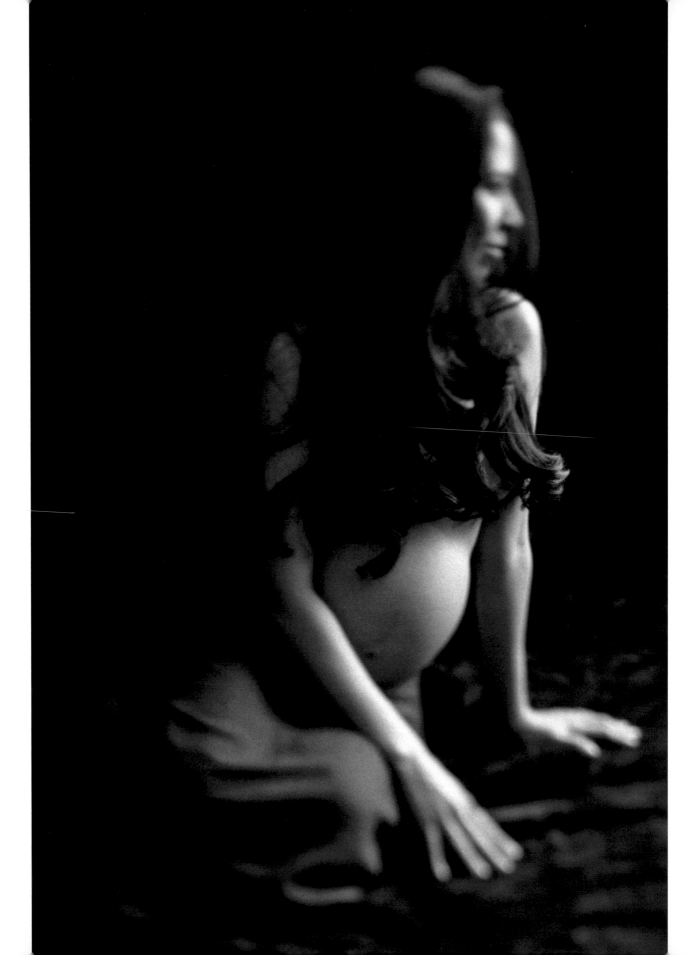

KAI

THIS WAS MY FIRST PREGNANCY AND EVEN THOUGH I WAS really excited, I was unsure of how I would feel about my body changing and growing. But I actually felt better than ever, so healthy and complete in a way, like this was what my body was meant to do. I absolutely loved being pregnant! It was such a fun time for me. I was able to travel home to Hawaii during my pregnancy where I spent time with family and friends and where I felt my baby's first movements, some while swimming in the ocean. Both the pregnancy and giving birth were truly life-changing and life-enriching experiences that I reflect upon with wonder. My husband kept telling me that I had never been more sexy. I am amazed at how beautiful I was.

CYNTHIA

Y HUSBAND AND I HAVE BEEN BLESSED WITH THREE wonderful, joyful, endearing little boys. The gender of all three was a surprise at birth, and we are glad we waited to experience the awe of each discovery—no other surprise in life can equate to the feeling of meeting your baby for that first time. While it would have been nice at times to know if my little being was a boy or a girl, I am so happy that I waited because the moment of discovery was a special experience among my husband, me, and our new baby and didn't have the detachment we might have felt in making such a discovery in a doctor's office in front of an ultrasound screen. With all the anticipation, the surprise was magical.

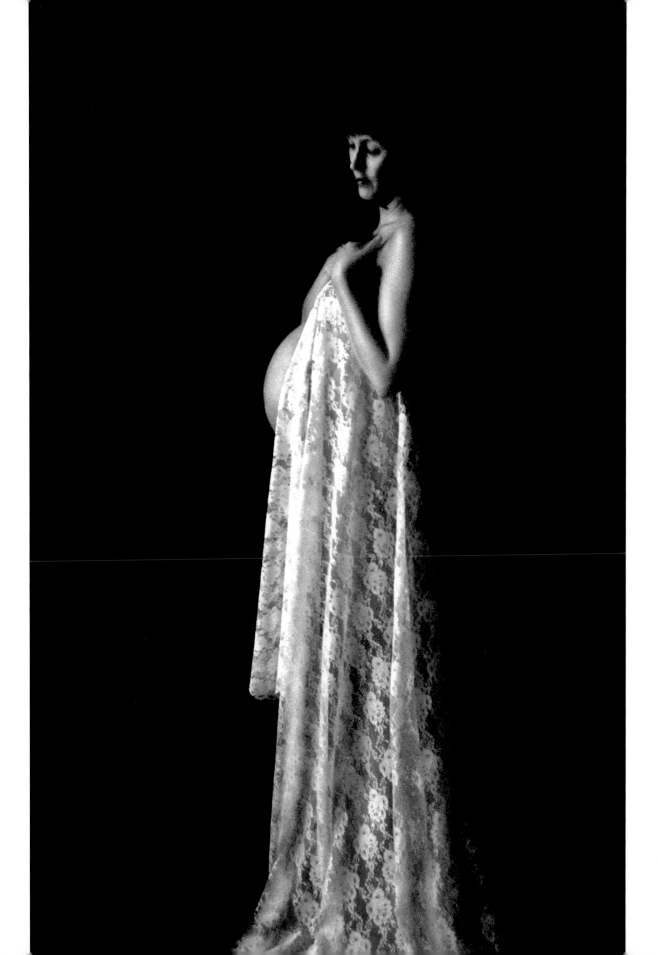

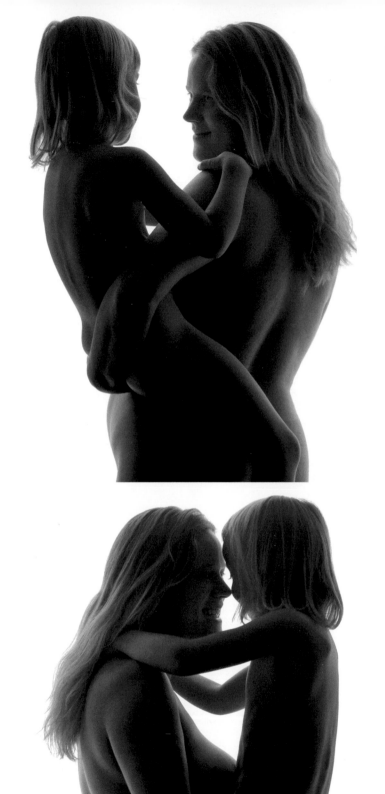

ASHLEY AND HER HUSBAND, THE MUSICIAN AND ACTOR DAVE MATTHEWS, moved to Seattle so that she could study naturopathic medicine at Bastyr University. About the same time, the couple started a family that now includes twin daughters, Grace and Stella, and a son, August. Being married to a successful, famous musician solved many everyday problems but also created extraordinary challenges for Ashley with her young family. Their lives had to allow for Ashley's education, being far from the support of close family members, homes in both Seattle and Virginia, and dad's career, which included recording sessions, long concert tours, and personal causes that demanded much of his time. But their priorities were clear: to keep their family together and to build a community around them in order to provide stability for the children who were growing up in lives that were sometimes anything but ordinary.

ASHLEY

MY HUSBAND AND I ALWAYS HAD A RELATIONSHIP FILLED WITH TRAVEL AND long distances. We spent months at a time together and then spent months apart. I knew what I was getting into when we got married and when we decided to have children. I feel like I signed up for that kind of life.

When we discussed beginning a family, we talked about starting in about six months. Of course, I got pregnant within a month. I never was apprehensive about being a mother. I had studied embryology, maternity issues, and pediatrics in school; babysat my entire life; and read all the books. Though I was among the first of my friends to have kids, I was confident and excited. During my pregnancy I was blissfully naïve about the challenges of motherhood, let alone the challenges of having twins.

Nothing could really prepare me for this transition. There are no words that could explain what it felt like to meet and hold my babies and how it absolutely changed my life and priorities forever.

After the girls were born we made a conscious decision to try to keep our family together as much as possible. That meant a lot of traveling, going on the road for months at a time or relocating our family for studio sessions and movie shoots. At a time in the girls' lives when all the books emphasized the importance of routines and familiar settings, we were on the road sleeping in a different hotel room every other night. I had to

redefine the meaning of home to be wherever we were. One way we made it work was for the girls to always be in bed with us at night. The family bed became our home.

As a result, we have the most enormous bed you've ever seen. In our house in Virginia, we put king- and queen-size beds next to each other. And in Seattle, we have a king and a twin. Now that our son is here, the girls have their own beds, but inevitably they end up in our bed in the middle of the night. David and I embrace this ritual. It is a time we know we can all be together. He might be away all day, but he will be there when we go to sleep and when we wake up. This gives the kids a kind of stability, a sense of home no matter where we are.

This worked well when we had just the girls because they are heavy sleepers who adjusted easily to changing schedules. My girls could fall asleep on my shoulder at 11:00 p.m. and sleep with us until 10:30 the next morning. We adjusted their schedule to ours so we could all get the sleep we needed. This did not work with their little brother.

He is an early riser and very light sleeper. He really changed the dynamics of things, as he likes to wake up at 6:30 a.m. no matter what time he was put to bed. That made for an interesting summer and a very tired mama. But we worked things out. The girls kept Dad company on the road for longer stretches, and I stayed home with our early riser, taking our son with me to visit them for shorter periods.

Even now, two weeks rarely go by that we don't spend at least a few days together. Sometimes that means David will fly home overnight after a show so that he can be here when the kids wake up, even if it's just for twenty-four hours.

As the children have gotten older, we've had to make big decisions about how much time to spend in one place for the benefit of the children socially and academically. We had to weigh how important it was for us all to be together versus how important it was for them to be in school and spend time with their friends. This made the people we surround ourselves with very important.

*Nothing could really prepare me
for this transition. There are no words
that could explain what it felt like to
meet and hold my babies and how
it absolutely changed my life
and priorities forever.*

I had to create a community of people the children could emotionally rely on. I feel privileged to have the resources we do. We're incredibly lucky, and I could hire a whole army of people to help take care of my children. But like any parent, I didn't feel confident leaving them with just anyone.

I was extremely fortunate when my daughters were born that my good friend and college roommate was looking for a job and wanted to get out of Virginia. She was my right hand and the second mom for the first two years of the girls' life and still plays a major role, acting as a doting aunt who often calls to check and see how they are doing.

Dave's guitar technician is also a huge part of our children's lives. He is like an uncle to them. He's always around when Dave is on tour or in the studio. And when the girls watch one of their father's shows, they always hang out in his space on the side of the stage. He's even come out to Seattle and picked them up from school every day when we've both been on vacation.

Not only do we have amazing friends but we also live in a wonderful, community-focused neighborhood, where people really look out for one another. Our neighbors are quite protective of us. Our kids go to a co-op school down the street. Every parent is part of the workforce at the school, and we all spend at least three and a half hours a week in the classroom.

I try to keep things as normal as possible or at least try not to make a big deal about the things we get to do. That's not always easy. Like when the girls tell their friends about what they did over the weekend—they went to Iowa so their Dad could play at a rally for Barack Obama—"Oh and by the way, we got to meet the Dalai Lama yesterday." You could call it denial, but I do not want to focus on how our family is different.

AMY

Before becoming a mom I was a visual artist and belly dancer. I liked being the center of attention and living an "alternative" life. This changed, more than I expected, once I had my daughter. My life's work, my passion, became being the best mom I can be. I still enjoy my previous endeavors but no longer feel compelled by them. I think about the consequences of all my actions and enjoy letting someone else, my daughter, be the center of attention.

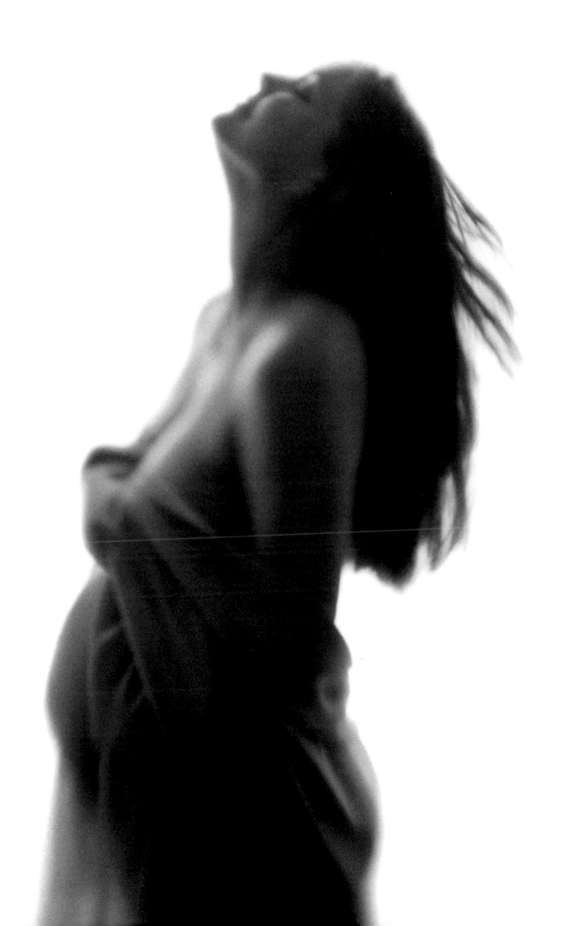

REV

I WAS WELCOMING A NEW PHASE OF MY LIFE WITH this pregnancy. I had just learned some of life's lessons, and I had found peace and spirituality.

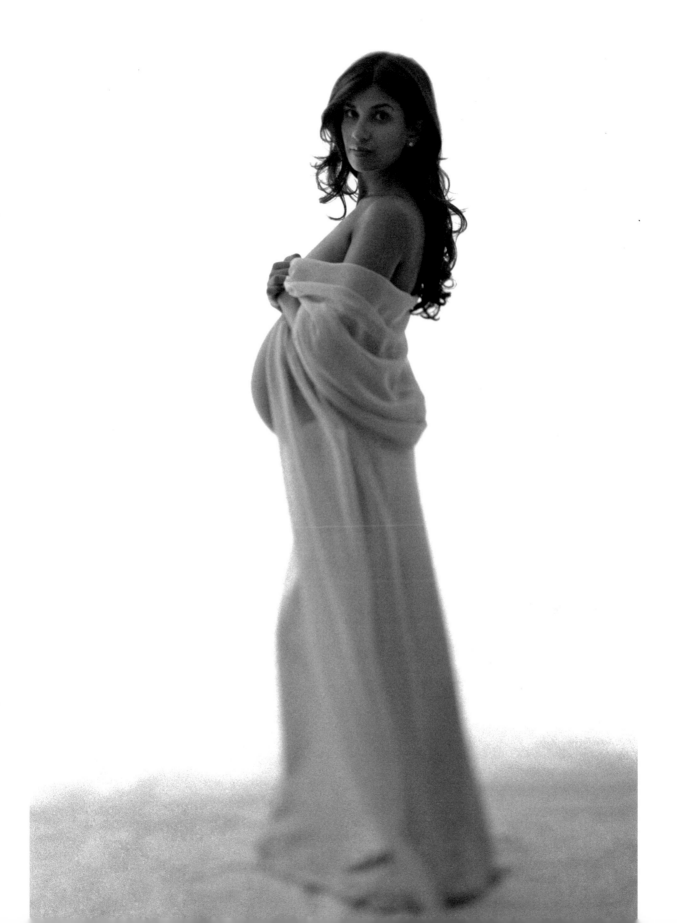

MARYA

I WAS SO LUCKY TO HAVE FALLEN IN LOVE WITH MY BEST friend. We were both excited and a little bit scared but definitely in this together, figuring it out one step at a time. Having Paul's unconditional love and support in his quiet and constant way is why I believe I had the world's easiest pregnancy.

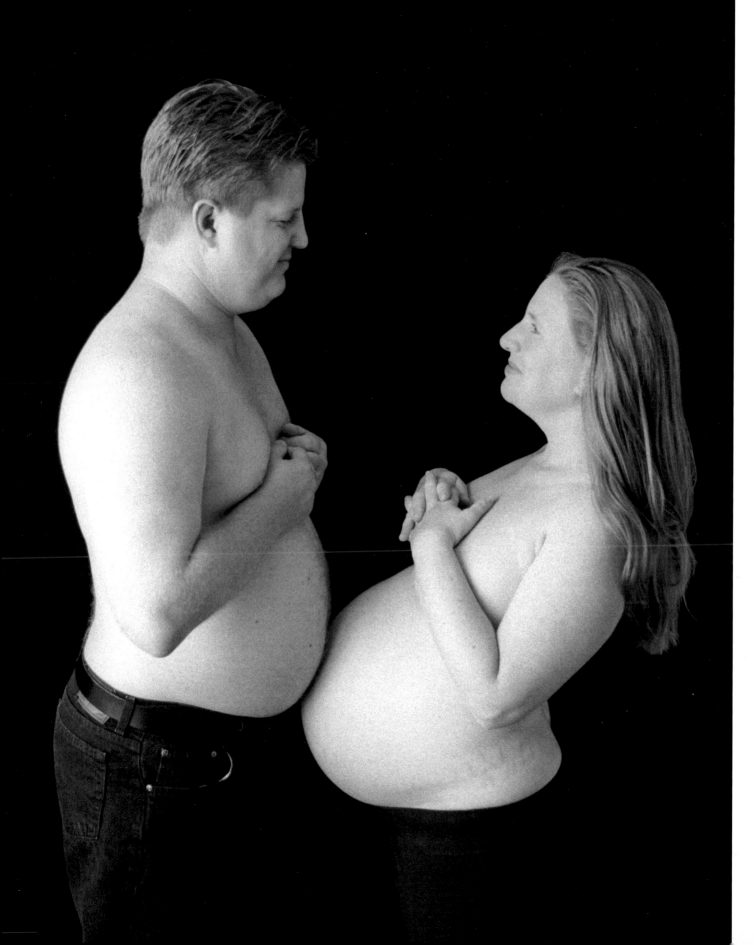

ANNE WAS NOT JUST A RELUCTANT MOTHER; SHE WAS OPPOSED TO motherhood entirely. She was in her early twenties when her son was born. By then, she had come a long way. She had shed a destructive compulsion, left home with nowhere to go, and survived for months living out of her car. She found work as an apprentice to a plumber, with whom she later fell in love. They got married and ran a business together. She worked long days and never thought about starting a family. She was diligent about taking her birth control pill, but got pregnant anyway and gave birth to a son, Samuel. Having a baby was even harder than she imagined. But eventually she realized you don't have a baby as much as a baby has you.

ANNE

I HAD SCARS BUT HID THEM WELL. FOR TEN YEARS, I WORE ONLY LONG-SLEEVED shirts in public. Starting at eleven years old, I coped with life by cutting myself. Some people use it as a form of self-punishment, some as a way to relieve guilt or sadness. Cutting is something that demands your complete attention, so you can't feel any guilt or sadness.

For me, cutting was a tool, and I used it when I needed it. But when I left home, I left it behind. I was free from other people's expectations. I didn't have to worry about letting anyone down. I had already done everything I possibly could to disappoint them.

After leaving home, I planned to attend community college. I would apply to Western Washington University, major in biological anthropology, transfer to the University of Washington, and become a neurosurgeon. I got as far as applying to Western. I got in, paid the registration fee, but never enrolled.

Instead, I worked as a housekeeper at a hotel and lived out of my car, a 1991 Plymouth Acclaim. I parked at the public library, next to the police station. I showered at the YMCA. I kept canned food, candles, and books in the trunk of the car. I used computers at the local college. Strangely, I really enjoyed it. This was the first time I felt completely free of any obligations or responsibilities. I could do whatever I wanted.

One day I interviewed for a job as a plumber's apprentice. During the interview, I was asked math and chemistry questions like what is the square root of nine, or what is the chemical formula for carbon monoxide. Even though I was homeless, I looked clean,

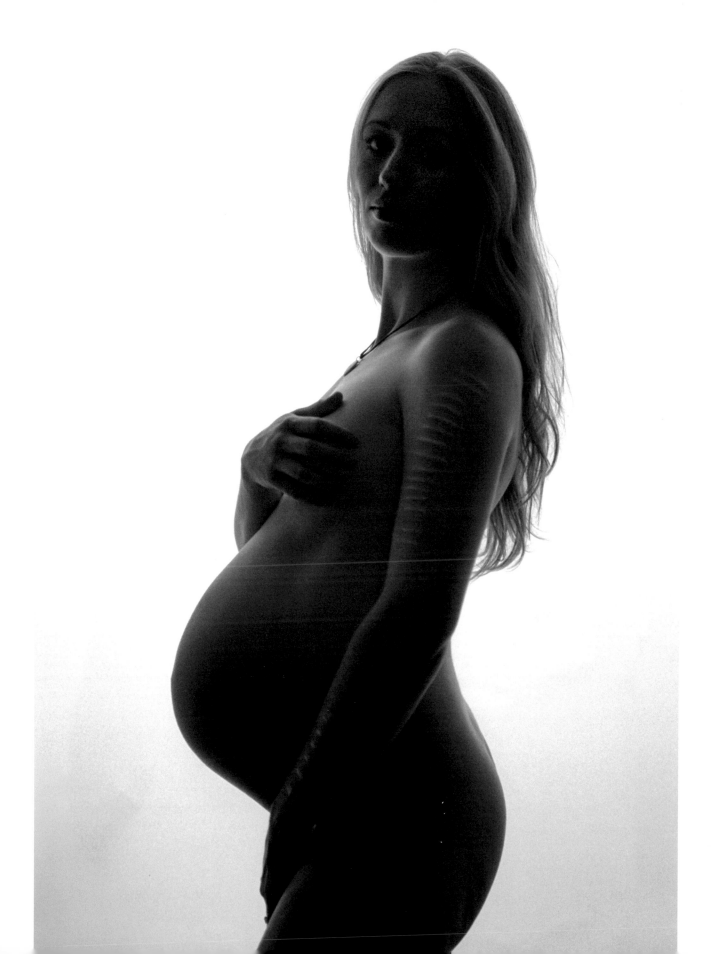

*I suppose for some people love
just happens. For me, it had to grow.
With both my husband and my
son, love was far from instantaneous.
But quietly and slowly, love put down
its roots and, in time, it bloomed.*

wasn't a drug addict, and could answer the questions that were asked. I didn't know anything about plumbing, but surprisingly I was hired. Dave trained me in the skills of the trade and I learned quickly. We developed a friendship, which gave way to lust and eventually to love.

Samuel was definitely not part of the plan. I had always said I would never have kids. I wasn't one of those women who thought babies or small children were cute. To me, they were noisy, smelly, obnoxious, time-consuming, and expensive. So when I took a pregnancy test and saw a positive result, I felt like I had fallen out of a tree. My head went a little bit fuzzy; my heart jumped into my throat. After that first shock of adrenaline wore off, I was a little bit frightened. I started thinking about all the hazardous work I had been doing that month.

I'd used glue and primer that were extremely toxic. I had breathed soldering fumes, and a heavy mirror had fallen off a wall onto my back.

When I told Dave, he was ecstatic. He is eighteen years older than I am, but unlike me, he had always talked excitedly about having children.

Other than the terrible morning sickness, I actually enjoyed being pregnant. I enjoyed the attention from strangers, and I especially loved the way Dave looked at me. I wore clothes that showed off my bulging belly. I had years of practice hiding parts of my body. Now, I was showing it off.

But my bliss suddenly ended when Sam was born. At the time, Dave had to work day and night. So when I came home from the hospital, I was all alone with a screaming infant and had no idea what to do. Sam wasn't the kind of baby who was easily soothed. He didn't sleep peacefully. He cried loudly and constantly. I hardly ever slept and cried constantly too. How stupid was I to think that having a baby was a good idea? I wished I could just take Sam back to the hospital and leave him there. I wondered how Dave would react if I suggested we give up Sam for adoption.

Samuel was definitely not part of the plan.
I had always said I would never have
kids. I wasn't one of those women who
thought babies or small children were cute.
To me, they were noisy, smelly, obnoxious,
time-consuming, and expensive.

All I could think was, "When is he going to stop crying? When is he going to stop peeing in my face? When is he going to stop spitting up?" When he cried, he was inconsolable. I made sure he was fed, that his diaper was clean. I held him, rocked him, comforted him. None of it worked.

One day, I just couldn't handle it anymore. So I put him in his crib, left him there crying, and went outside where it was quiet. When I came back five minutes later, he was asleep. It took me a while to figure out that Sam couldn't fall asleep when someone was holding him; it was too much stimulation. This never occurred to me. It never occurred to my mother or doctor either. To this day, he doesn't like to be rocked to sleep. Once I figured out how to get Sam to sleep, I started getting more sleep too.

Then when he was three months old, Sam smiled at me. It took that smile for me to realize that he wasn't just a baby: he was a person. A person who will grow. He will go to school. He will like art and hate math, or maybe the other way around. He will collect interesting rocks, or toy cars, or perhaps both. He will grow into a man, have a career, a wife, maybe even kids of his own.

I suppose for some people love just happens. For me, it had to grow. With both my husband and my son, love was far from instantaneous. But quietly and slowly, love put down its roots and, in time, it bloomed.

Now I'm one of those women who sees a baby in a grocery store and gets all misty-eyed. I've become emotional in ways I never was before. It's like my brain has developed a connection that didn't exist until I had a child.

I don't hide my scars anymore. I don't think about them except when I wonder how I am going to explain them to Sam when he gets older. I'm worried about his friends coming over and seeing my scars, about their mothers being concerned.

You can see my scars in the photographs. I like seeing them. They show how things used to be and who I've become.

CRISTINA

WALTER AND I MET AT THE LIBRARY. HE SAW ME STANDING behind a counter and started talking to me. I wasn't receptive at the time because I was with someone. But Walter was determined to get me, which took a couple of months and that was eleven years ago. I think what makes our relationship work is that we understand and accept each other. We accept each other's good and not-so-good qualities, and we love each other unconditionally. Of course each of us has bad days, but we always try to focus on the positive. When we do have disagreements, we try to disagree constructively and accept that at the end of the day it is okay to agree to disagree. Our relationship is based on more than just trust. We are a team and love each other without bounds.

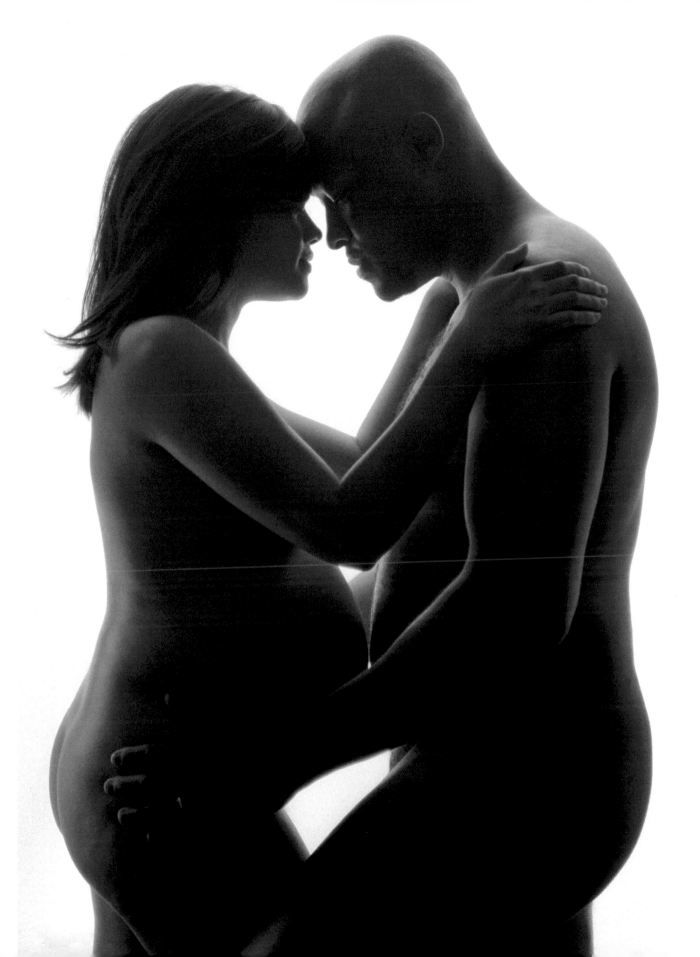

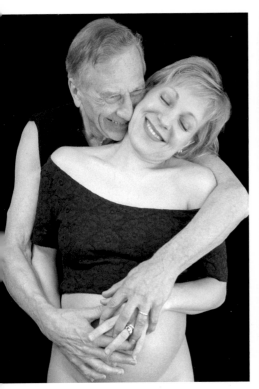

KAREN

I WAS ENGAGED TO SOMEONE IN GRADUATE SCHOOL, BUT THINGS weren't really that great. I was having serious second thoughts about ending it, but I kept thinking that he would change once we got married. The other reason I stayed in the relationship was that I just wanted to be loved by someone so much.

I am a very practical person and I used to think that love at first sight was dumb. Then Fred walked in the door, and I fell in love the second I met him. He was my graduate program director. We were together for about a year before we got married. Twenty-one years later I can still say we have had the most wonderful marriage; he is everything I could have ever hoped for in a man and a husband.

We tried to have children for sixteen years, trying everything the infertility world had to offer. At the end of multiple failures, the doctors said I couldn't have children. Five years later, I had a dream one night. In my dream I was in the presence of light and felt like I was immersed in love. Like love itself surrounded me. Soon after I found I was pregnant with Kathryn.

Being a mother to Kathryn has given me some insight into how God must feel about us as His creation and His children. How much He loves us—and how much He still loves us even when we don't do things the right way— how He can see our failures and foolish choices and understand the "why" behind them. I don't think I would have ever understood this kind of love if Fred and I had never had Kathryn.

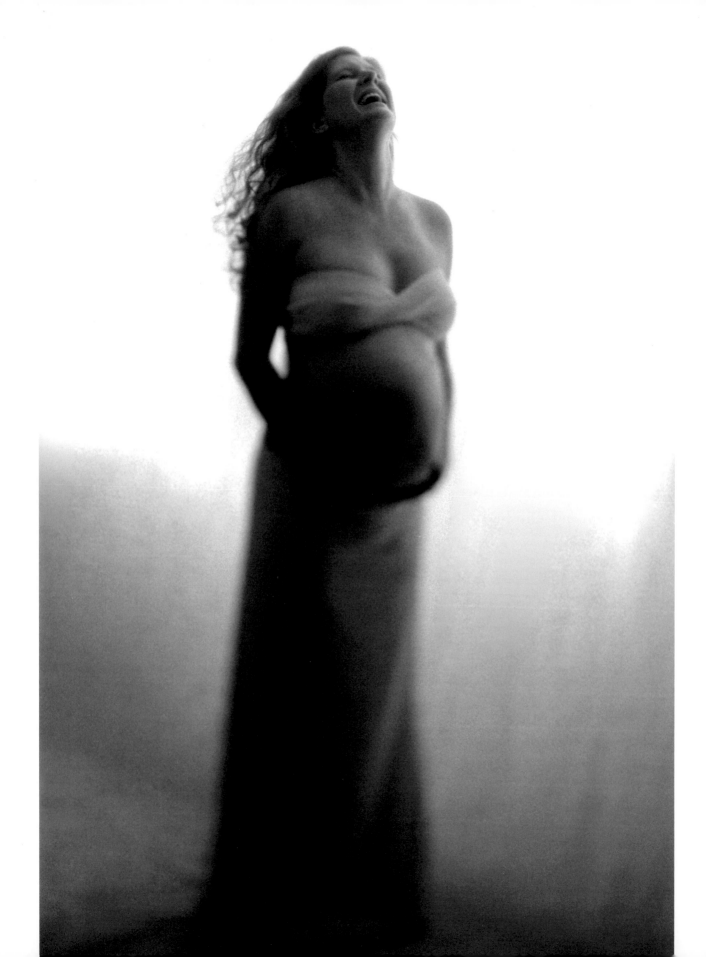

JULIA

THE FIRST HALF OF MY PREGNANCY I FELT LIKE I WANTED TO DIE.
I was throwing up beyond control. By twenty weeks, the halfway
mark of the pregnancy, I had lost fifteen pounds and was receiving regular
IV fluids to stay hydrated. The antinausea medications made reading virtu-
ally impossible, the smell of my husband turned my stomach (especially if
he had eaten garlic—the traitor!), and I spent most days in bed. I tried
everything and then heard about a physician who did hypnosis. I decided
it was worth a try. After two treatments I was eating like a normal pregnant
woman. In the next twenty-one weeks, as a repercussion to my weight loss,
my body gained seventy pounds, holding onto every calorie I ate. With this
extra weight, the front of my pelvis separated, making every movement
painful. So much of my pregnancy was spent trying to get through the day.
This photo is from a wonderful afternoon where we celebrated the beauty
of my pregnancy, the love and joy of expectation, and I felt elegant. This
was one day I felt great.

WHEN CASSIE AND LISA DECIDED TO BECOME PARENTS, THEY CONSIDered the usual options for lesbian couples. Adoption was one possibility. But Cassie deeply wanted to experience pregnancy, never mind the hurdles they might face as a gay couple looking to adopt. Once they decided Cassie would give birth, they had to make a decision about the sperm donor. Would he be an anonymous donor or someone they knew? The couple ended up having two sons, Sam and Gus, with a donor they knew well. It was a weighty decision that came with unexpected results. Somewhere along the way to motherhood, Cassie and Lisa discovered the joys of . . . fatherhood.

CASSIE

E KNEW BY CHOOSING TO HAVE CHILDREN WITH A MAN WE KNEW THERE might be conflict as the kids grew up, about everything from custody, or how to raise them, to where we spend holidays. By choosing our good friend Frank to help us become parents, we think we're probably in the minority of couples.

Had we gone to a sperm bank, there would have been no legal contracts, no long discussions about our arrangement. We decided that using a sperm bank might have been simpler at the outset. But it won't be simpler when our kids start to ask questions about who their father is. This was the choice that felt right for us. We picked Frank because he is funny, giving, and caring—all traits we hoped he would pass on to our children.

We went through a really long process with Frank once he agreed to be the father of our children. Our lawyers drew up a lengthy contract that protects all of us. We agreed not to seek child support and agreed never to deny Frank access to our sons. Frank agreed to let Lisa have full custody of our children.

Our firstborn was Sam. We asked Frank if he wanted to be with us at the birth. He said no because he doesn't like blood and medical procedures. But when I went into labor, he showed up at the hospital just to visit. He intended to leave after a little while, but he ended up staying through the entire birth—and it was amazing having him there. That experience was the beginning of a strong connection between him and the kids.

We expected this to be a very good situation. We imagined a positive relationship, but a limited one, like an uncle maybe. But it has turned out to be exponentially better than we expected.

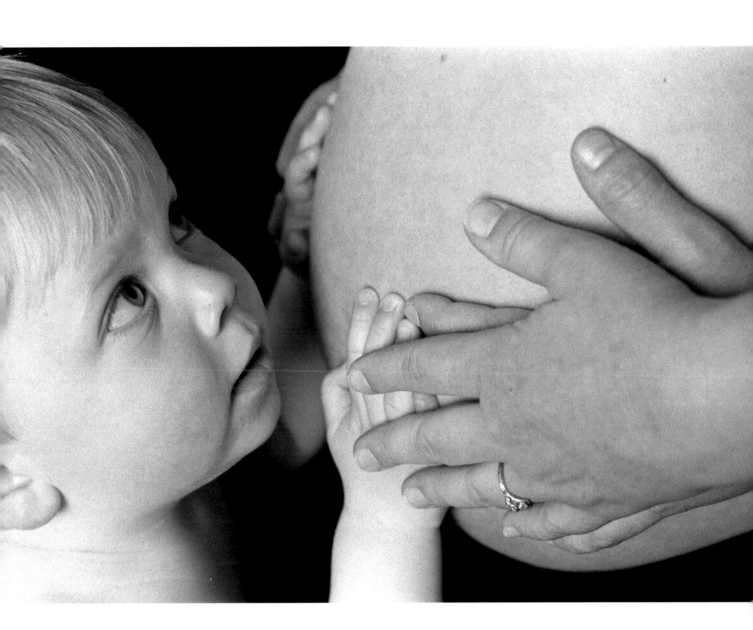

We decided that using a sperm bank might have been simpler at the outset. But it won't be simpler when our kids start to ask questions about who their father is. This was the choice that felt right for us.

Frank has an incredible relationship with our oldest son, Sam, and his younger brother, Gus, who was born two years later. They see one another at least once a week.

Sam is very talkative, like Frank. Both boys have Frank's beautiful blue eyes. I see a lot of Frank in my sons. We hoped there would be a strong bond, but what they have is more than we ever dreamed. Our son Sam loves him so much, and we know Gus will too.

I have complete confidence in Frank's relationship with the boys. Frank knows everything there is to know about them. So we never have to wonder or worry when they are together. They have a very natural relationship. We won't have to sit the boys down in ten years and say, "There's something we have to tell you."

One important reason I think our arrangement works is that Frank probably doesn't really want to be a full-time father. He was very well established in his life. This way he can spend as much time as he wants with our children but still have his own life. And as far as we're concerned if he wanted to come over all the time, we'd be happy. Of course, we never hesitate to call on Frank; he's always there when we need him.

And it's not just our relationship with Frank that is so rich for our family. It goes much deeper now because we also have an excellent connection with all of Frank's family. We had no idea how his family would feel. We imagined their reaction, "What do you mean you're having a baby with a couple of lesbians?!" But they have been nothing but welcoming and loving. Frank's mother is eighty-six; Frank is fifty, single, gay, and the youngest child. His family never thought he would have kids. And now he has two!

We've visited his family in Ohio. And they've come to visit us in Seattle. We feel like we and our children got a bonus family we never counted on. From our perspective, the more people that love our children, the better.

Shortly after Sam was born, we had to designate a guardian for our son should something happen to Lisa and me. There was no question it would be Frank. In our family, it's very clear who we all are. I'm "Mama," Lisa is "Ma," and Frank is "Pops."

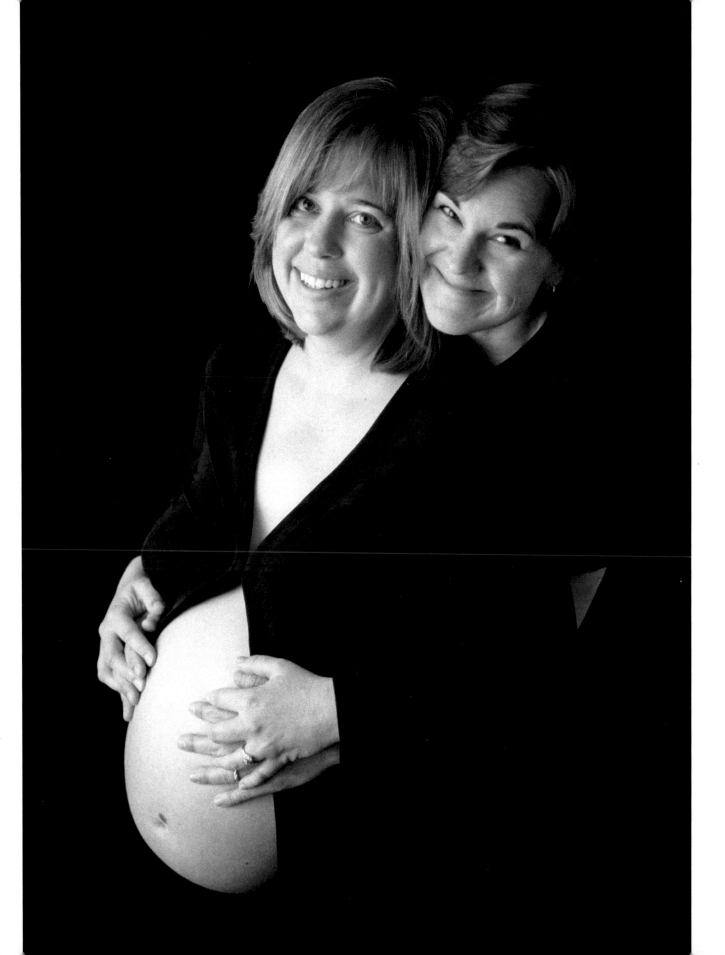

RONIQUA

BEING ON THE GO ALL THE TIME WITH MY CAREER AND my family, I thought a lot about how my life was going to change after my baby arrived. It was scary because I didn't know how I would handle everything. But after I had him, I just made different choices with my time and now I can't ever imagine being without him.

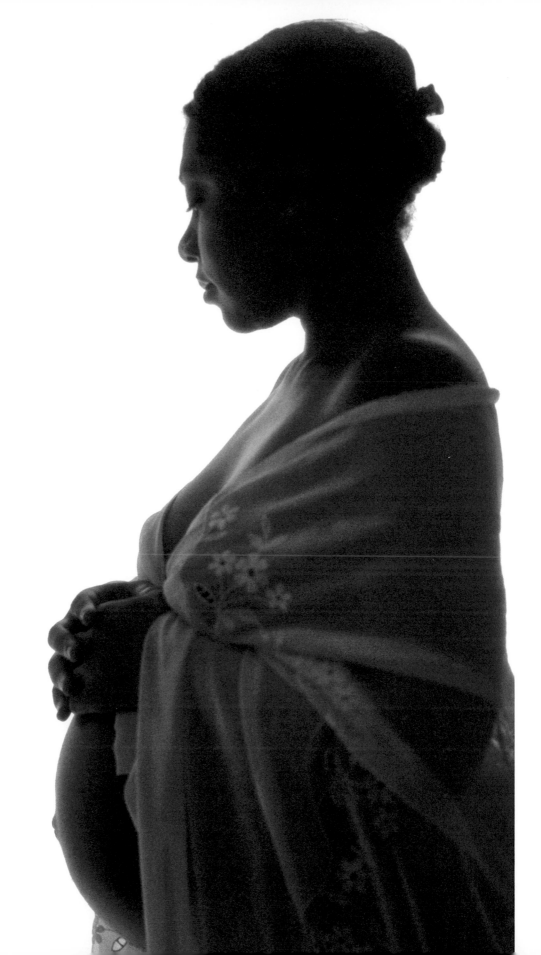

CARIN

I WAS PREGNANT WITH AVA, MY THIRD CHILD, WHILE I WAS in the midst of a painful separation, which would later end in divorce. Never in a million years did I think I would end up there, but that is what happened. I had these photos taken to capture this moment in our lives so that in spite of the difficult time, Ava would know how beautiful I felt when I was carrying her, what a special gift she was to us and how cherished she is. The experience was powerful and cathartic; I'm so happy that Téa, Jack Henry, and Ava will have these someday. It is a testament to how we began the process of healing and rebuilding. Someone once said, "When we experience pain, the universe lets our hearts expand and they grow back bigger." Now I know that is true. This is for my babies. Mommy will always love you.

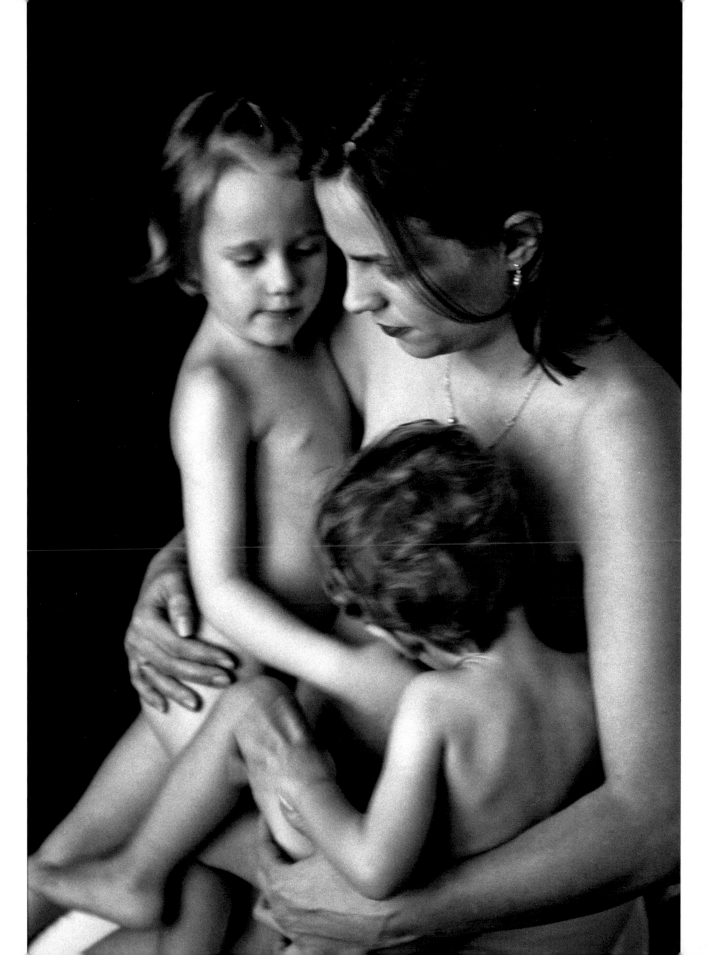

MICHELLE

BEING PREGNANT AGAIN AFTER FOURTEEN YEARS—AT THE same time my sister, Joanne (on left), was pregnant with her first baby—was wonderful! Sharing the roller coaster of emotions, the aches, and the butterfly feelings as our bodies were changing sealed our sisterly bond.

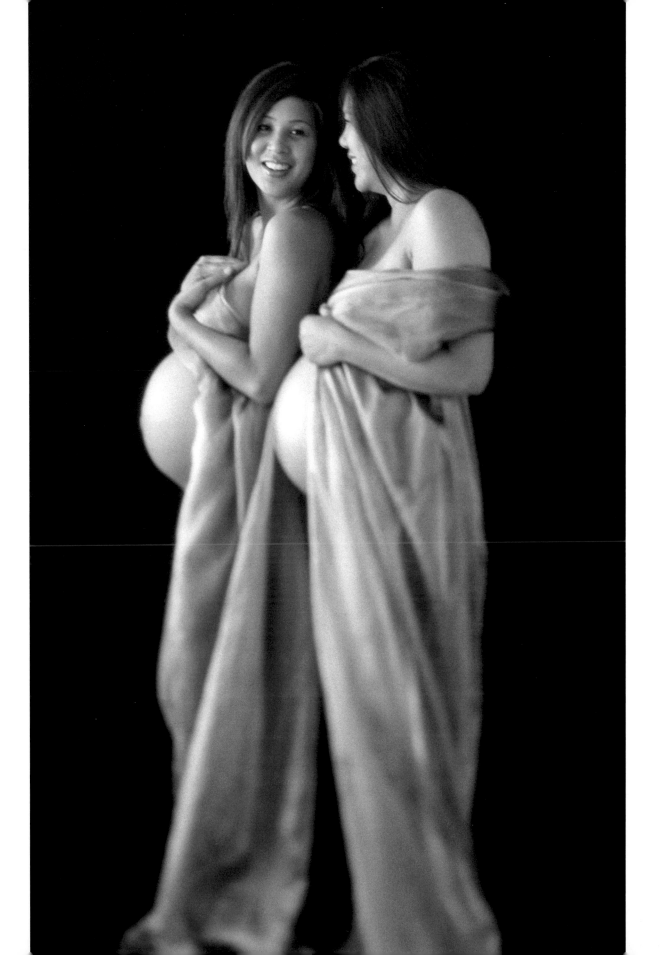

KRYSTAL

I WAS SOMETIMES AFRAID OF BEING A SINGLE MOTHER AT THE age of twenty. I had always envisioned myself starting my family when I was in my thirties with a wonderful husband and financial security. However, when I discovered I was pregnant I felt a sense of peace and calm wash over me. I knew keeping my baby was the right choice.

I was on bed rest in the hospital for over two months before my delivery. Every night before I went to sleep I read from one of my books and talked to my baby, Soleil, assuring her that we were going to be all right. During my pregnancy I would remind myself that everything happens for a reason and things would turn out all right if I kept a positive outlook.

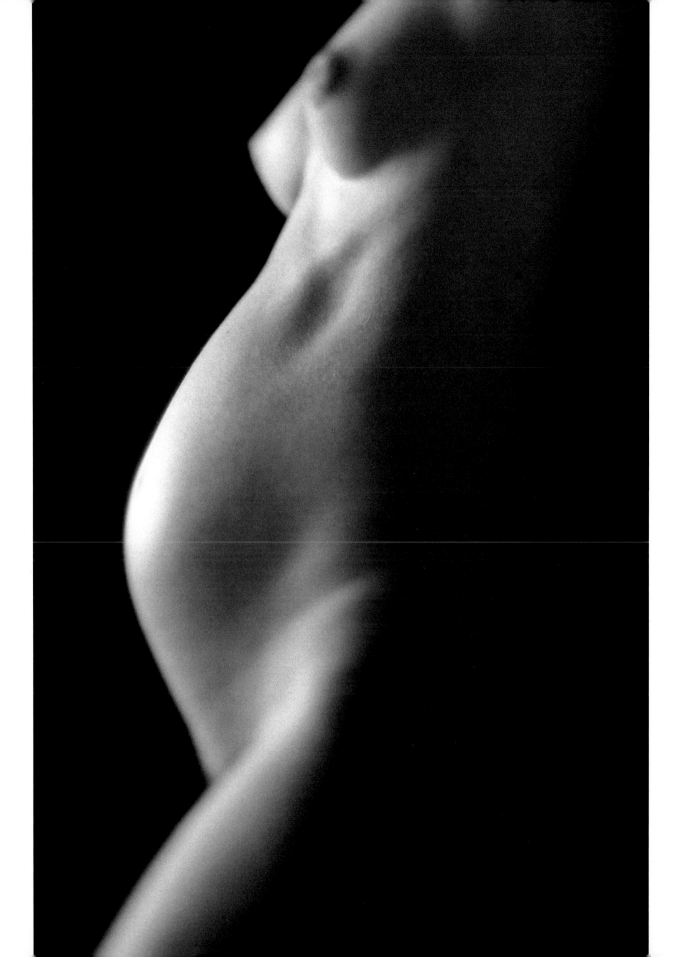

LIKE THE WOMEN SHE SAT WITH IN THE WAITING ROOM OF HER doctor's office, Jessica could not get pregnant or sustain a successful pregnancy. But what set her apart was her age. She was only in her twenties, noticeably younger than the women she saw around her. With guilt, because she knew it was unfair to think this way, she felt like she was being unjustly punished. The older women, she secretly thought to herself, had probably waited to have children and this was partly a consequence of that choice. Over time, she had to accept what she could not control and find her own way to motherhood.

JESSICA

I THOUGHT I WAS DOING EVERYTHING THE RIGHT WAY. I GOT MARRIED WHEN I was twenty-three and after one year, we decided we'd like to try starting a family. After about one year I still wasn't pregnant, which worried me. Six months later, I finally got pregnant. I was so excited. I might have been a little slow, but I was pregnant.

But three months later, I started spotting a little bit and I got the feeling that something wasn't right. I went in for an ultrasound and that's when I found out my baby had no heartbeat. I was only twenty-six.

Over the next few years, we tried just about everything to get pregnant. At first, we tried fertility drugs and then a combination of sperm washing and artificial insemination in which my husband's sperm was cleaned, washed, separated, and deposited close to my fallopian tube. We went the Eastern medicine route as well with acupuncture, massage, Chinese herbs, and electronic stimulation.

When that didn't work, we upped the ante by adding injections of an ovulation stimulation drug. We tried that for several cycles, hoping I'd produce more eggs. We had to stop when I discovered I had an endometrial cyst on my ovary that had to be removed. I also endured three laparoscopies for treatment of endometriosis, and removal of a diseased fallopian tube.

Not only did all these steps cost money, it was taxing emotionally and physically. The only other option for us was in-vitro fertilization. In preparation for the procedure, I took a lot of blood tests. We found out I had a higher than normal level of a hormone that

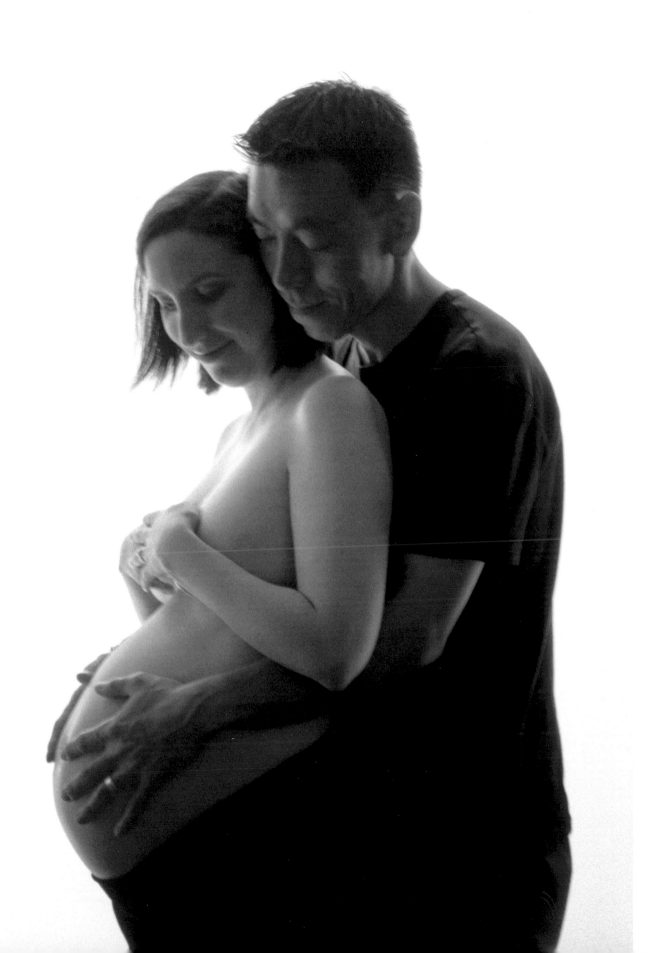

I lamented that my child wouldn't

have my hands or my intelligence,

my green eyes or my narrow feet.

Then I realized that my love and my

values are far more important things

to pass on than any genetic trait.

affects ovulation. It's one of the indicators of perimenopause. I was only twenty-eight, and my level of this hormone was almost twice as high as it should have been.

My doctor tried to reassure me by reminding me that I was very young. That's always what I heard: "You're so young. You're so healthy." She told me she had seen women with higher levels of this hormone get pregnant. So with that we went ahead with in-vitro.

It failed phenomenally. I was able to produce a total of about a dozen eggs. We fertilized eight of them. But those embryos just did not grow. We tried in-vitro three times and it failed each time. To make things worse, the levels of that hormone kept getting higher.

When I was younger, before I was married, I'd often said I didn't think I wanted to get married or have children. I just had a sense that was not the path my life was going to take. But when I met my husband, having children became the most logical thing in the world, and I wanted to start that right away. So years later when I couldn't, I wondered, "God, did I jinx myself by saying that?"

All our efforts to get pregnant were draining our finances. We're not wealthy people. We were dipping into savings, into the equity in our house, charging thousands on our credit cards. I don't think most marriages could have survived.

But if anything, this just made us stronger. When all of this started to happen, my husband reassured me by saying, "I chose you, and children are an option." But for me, it wasn't an option. As long as I've known my husband he's been great with kids. I couldn't imagine him without them. Throughout our journey to parenthood, he never missed a doctor's appointment. He was there for every ultrasound, every procedure. He gave me every injection though it pained him to do it.

The way I felt about my husband was one reason I decided to try donor eggs. In-vitro didn't work with my eggs, but maybe it would work with someone else's eggs. Another reason is that I really wanted to be pregnant. I wanted that experience. I wanted to have my husband's child. I'm not one who believes you have to have children in order to be fulfilled as a woman. But part of me feels this is what my body is supposed to do. It's what I was born for. And the idea that I couldn't really did affect my image of myself and my confidence as a woman.

So at age thirty-one, I sought to become a mother with help from a generous twenty-eight year old who gave us the wonderful gift of her eggs. It was not an easy decision to make. It seemed so unfair. I wasn't forty-five. I hadn't delayed pregnancy to pursue other goals. I lamented that my child wouldn't have my hands or my intelligence, my green eyes or my narrow feet. Then I realized that my love and my values are far more important things to pass on than any genetic trait.

We went forward with so much hope and ended up with five embryos, much fewer than we had anticipated, but more than enough to build our family. We transferred two embryos, hoping for twins, and froze the other three. Our dreams were dashed yet again. I miscarried.

This was the hardest loss. We had created the perfect situation: good eggs, good sperm, a healthy uterus. This was supposed to work! Even the doctors were upset. We had no answers and another round of tests provided no additional insight. My immune system was not attacking the embryos; my husband did not have some rare genetic flaw. We had no reason for failure.

After taking some time to recover we tried again with two of the frozen embryos. We had little hope due to the decreased odds present in any "frozen" cycle. Amazingly, I was pronounced pregnant two weeks later. We had little time to celebrate before I miscarried again in week five. We were devastated, but strangely had just come to accept defeat. It had almost become inevitable.

We began to consider adoption and contemplated a life with no children. We had one more frozen embryo, but no hope that it would produce a baby. We decided to have it transferred into my uterus because, well, what else would we do with it? If we didn't transfer it, we had to discard it, and that seemed irresponsible. That was probably the only reason I even bothered trying again.

My attitude was almost, "just get it done and have it fail, and put me out of my misery." Somehow, against all odds, this little embryo had another idea. My last chance turned into a miracle. My daughter's name, Amadea, means "God's beloved," and I truly think she is.

The majority of my family did not know I used a donor egg. I didn't tell a lot of people. I intend to tell my daughter because it's part of who she is. I want her to understand how much we wanted her no matter the source.

My pregnancy was so healing for me. Infertility had robbed me of my faith in my body, of my love for it. I felt like my body had betrayed me because it couldn't fulfill its most primary function. Being pregnant gave me back my body. I had a newfound respect for it and was in awe of my changing shape. I felt that I was evolving, becoming the person I was meant to be: my daughter's mother.

All our efforts to get pregnant were draining our finances. We're not wealthy people. We were dipping into savings, into the equity in our house, charging thousands on our credit cards. I don't think most marriages could have survived.

NANCY

MAX IS MY THIRD CHILD. I HAD TRIED TO HAVE A natural, drug-free birth with each of my two girls and although I did have natural labor, neither was drug-free. I had heard about other women's beautiful and easy births and desperately wanted a drug-free labor for my third. I went to hypnobirthing classes because the concept of no-fear-no-tension-no-pain rang true to me. I discovered I was able to relax and work with my body, instead of tensing up and fighting the natural birthing process. As I delivered Max while kneeling on the hospital bed, I remember thinking, "Wow, I can feel this. This is right. Our bodies know exactly what to do to give birth. This is natural and unbelievably beautiful!"

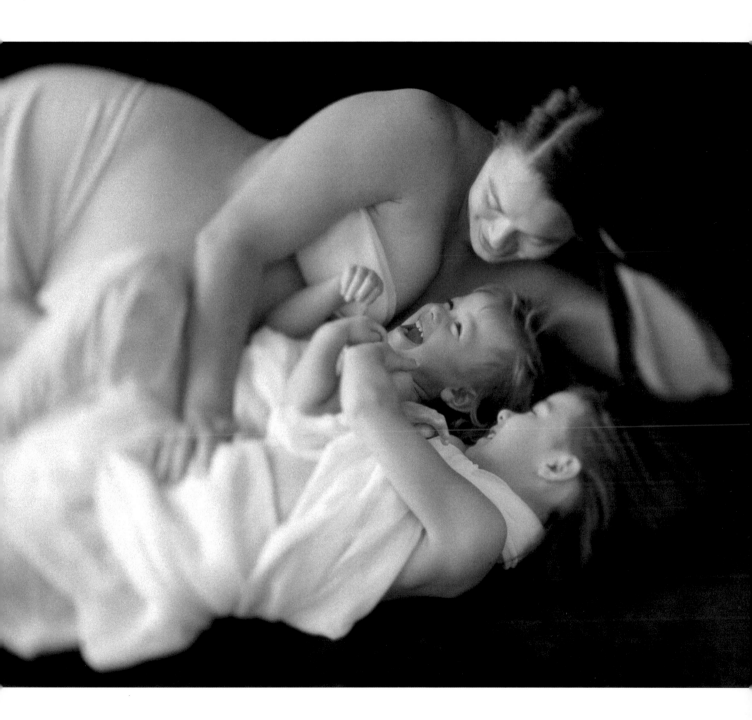

LORRAINE

AS A FILIPINO WOMAN, WHEN I WAS PREGNANT I WAS expected to stay home, hide out, and wear big clothes. Culturally, I was not encouraged to draw attention to myself. But I was first-generation American, and this helped me burst through those customs. Instead of hiding my body, I wanted to revel in it. I felt beautiful and really wanted to celebrate it. Pregnancy is such a wonderful part of life, and there were no photos of my grandmother, mother, or aunts pregnant. Those memories are missing from our photo albums. Like first you are cute, then you get married and have a beautiful wedding photo, and then all of a sudden you have a kid. Pregnancy is a part of the whole process. I want to share this memory with my kids. I want this in their photo album.

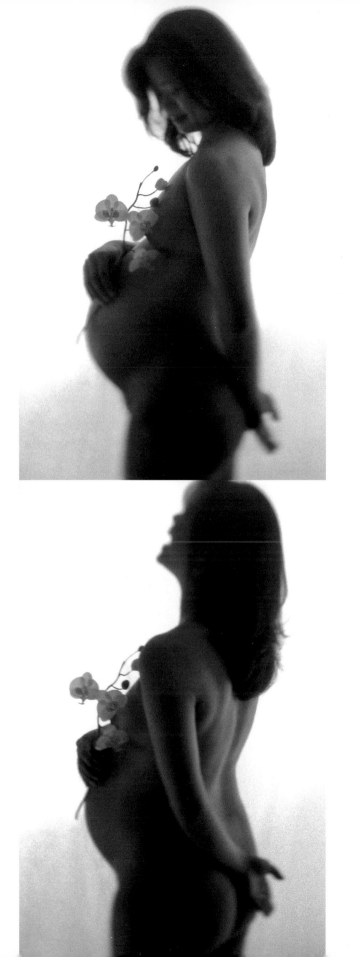

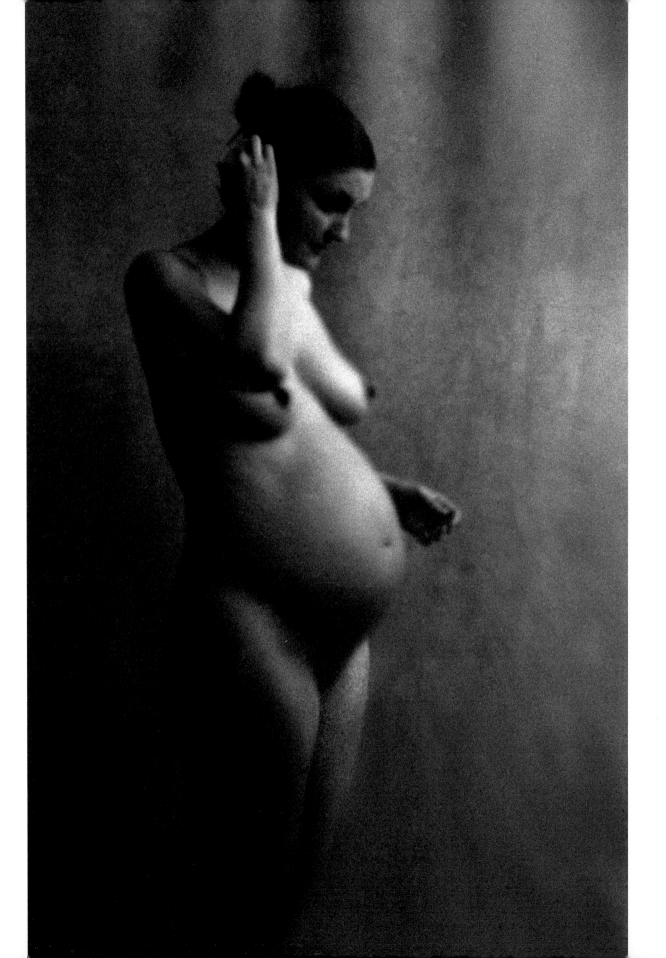

AMY

I REMEMBER WANTING TO BE A MOTHER SINCE EARLY childhood and very much looked forward to pregnancy. After careful planning and one miscarriage I had succeeded in the pregnancy part and I hated it. I felt body snatched and totally out of control. I also had the new fear that if I hated pregnancy this much maybe I would hate motherhood too. Pregnancy would be over eventually but motherhood is the rest of my life . . . yikes! Fortunately, I love being a mom so much that I would even consider going through pregnancy again though, honestly, I would rather adopt.

HILERY

URING MY PREGNANCY, I WAS WORRIED ABOUT HOW THE stress of running my own business would affect my son even while in the womb. In the end, I had to come to terms with the fact that I cannot always be perfect for my child or provide the perfect environment. I did what I could to relax through my pregnancy and kept my life moving forward.

One of the things I noticed when I was pregnant was how kind the world became. When I was shopping for clothes, I became light headed and grabbed a counter for support. Within minutes, I was seated on a chair with snacks and juice set before me. It was amazing how pregnancy crosses social barriers and brings women together.

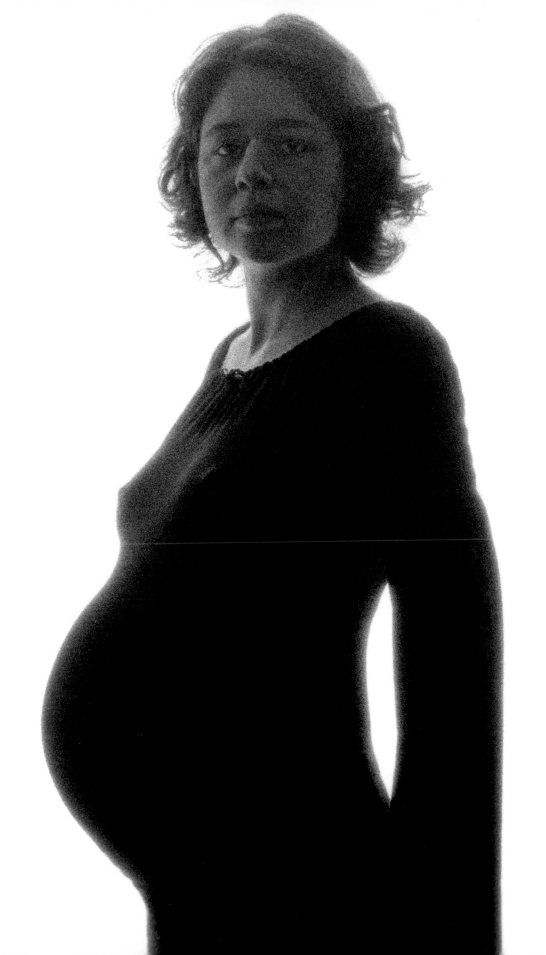

HAVING JUST TURNED FORTY, MARI WAS NOT A TYPICAL UNWED mother. A brief relationship that had ended amicably without tears or heartbreak had also resulted in an unplanned pregnancy. Undaunted, she decided to have the child on her own, leaving it up to her baby's father to decide whether he wanted to be part of his child's life. The decision was the beginning of an unconventional but very happy family that would grow in unexpected ways.

MARI

HE WAS WHAT PEOPLE CALL THE REBOUND. I DATED HIM FOR A FEW MONTHS after coming out of a long relationship. We realized we weren't a good fit and broke up with no hard feelings. A little while afterward, I found out I was pregnant. My first thought was that having a child at this age, on my own, just wasn't for me. My job was demanding, and I didn't want to face this responsibility alone. But at the same time, because of my age, I felt blessed to be pregnant. I had always thought I'd have children at some point but with someone I loved. And then there was the baby's father.

After our break up, he had moved on and was already in a happy, steady relationship. A baby was going to affect his life and the life of his girlfriend. I told the baby's father he could simply walk away if he wanted to. But he said he wanted to be a part of the baby's life.

For months, I didn't dare get too excited about the pregnancy, not knowing if I would go through with it.

I thought back to when I was twenty-five and still living in Sweden, where I'm from. I was engaged to be married to a very nice young man. Had I stayed there I probably would have married him, had a few children, and settled into a normal life. But instead, I chose to make my career my first priority. My job required a lot of international travel. My fiancée and I grew apart.

So now, here I was. I was in my forties, single, still traveling a lot for work, living far from home in California, and suddenly pregnant with the child of a man I had never

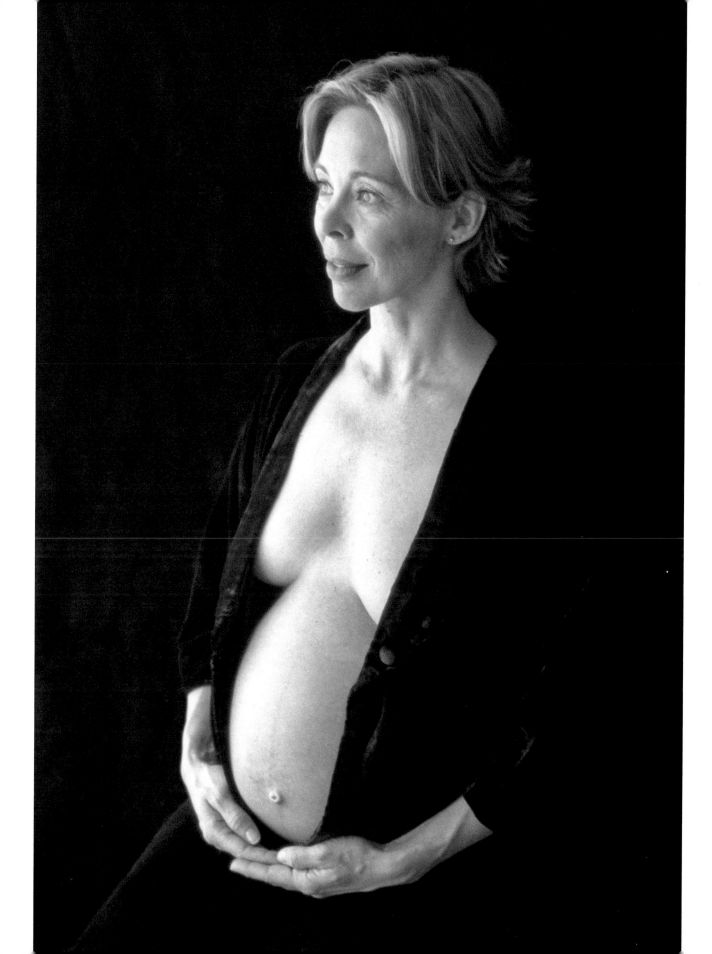

expected to see again. I wasn't sure I had the money or the time to do this on my own. I didn't even know if I'd be a good mom. I wasn't a "natural" around babies like some women I knew.

The turning point in my thinking came after I spent time with one of my best friends, who had given birth to her son a year earlier. Seeing how happy and excited she was got me excited too. I decided I wanted to have the baby. Soon, I found out I was going to have a son.

The birth of my son, Maxwell, was the greatest joy of my life. His father embraced this new addition to his life and is a wonderful father to Max. In time, he married his girlfriend and they had a son together. Now Max has a half-brother. It says so much about Max's father and perhaps even more about his wife that they both welcomed Max into their lives. They are amazing people who responded with grace to a complicated situation.

Becoming a mother to Max, experiencing that joy, is what convinced me to have another child. I considered adoption but decided first to try in-vitro fertilization using an anonymous donor. While Max was unplanned, my second child was really planned, and I mean seriously planned. I had to give myself shots every day, and I'm terrified of needles. But I really wanted another child. Max was such an incredibly nice surprise; I just knew I wanted one more.

So at age forty-five, I gave birth to my daughter, Ella. She looks just like Max so most people probably assume they have the same parents. The truth, of course, is a different story, but a very happy one. Some of my closest friends have told me they could not even imagine doing what I did. Of course I would never have considered having Ella had I not accidentally become pregnant with Max.

When I found out I was pregnant with Max, I was on vacation in Italy with a dozen friends. It was five in the morning. I woke up my best friend and told her. Then I went out and looked at the sunrise. I thought to myself, "What am I going to do? Oh my God, I'm pregnant." I just sat there. Part of me felt special to be pregnant. Part of me didn't know how to feel.

I never felt miserable or that it was a bad thing. I was more unsure and nervous. I remember smiling, eating my yogurt and thinking to myself, "This could be something really, really amazing, even if it feels a bit scary." Somehow, I felt really special. Maybe I had a sixth sense that this would turn my life around in the most wonderful way.

I was in my forties, single, still traveling
a lot for work, living far from home
in California, and suddenly pregnant
with the child of a man I had
never expected to see again.
I wasn't sure I had the money
or the time to do this on my own.
I didn't even know if I'd be a good mom.

CARRIE

I ANTICIPATED NOTHING, I KNEW NOTHING, I UNDERSTOOD nothing. You hear others' stories and experiences but I think pregnancy is one of those experiences, like being a parent, that nobody can really prepare you for. There were so many things I could not anticipate: how stuffy my nose got, how many different crib sheet sets there are to choose from in this world, and how I could hardly put my own socks on near the end.

The thing I enjoyed the most, and miss the most, about being pregnant is feeling the baby move inside of me—the rolls and twists and turns, the skimming movements across my torso. And all the different shapes my belly could take on in one day's time. From the first flutter, I loved it. Even when the doctors say you can't feel it yet, you can.

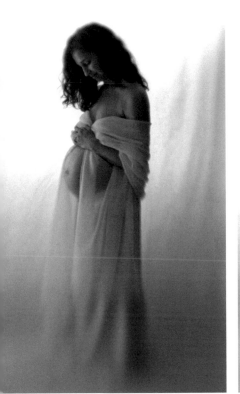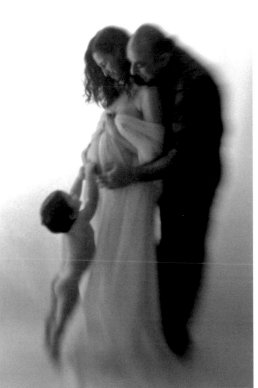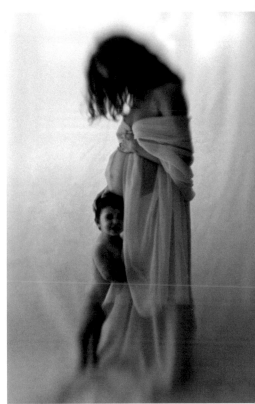

DENISE

OUR DAUGHTER WAS BORN SIX WEEKS EARLY, TWO WEEKS after we were married. We had hoped to have a little more time as just husband and wife, but she decided it was time for her to come at thirty-four weeks. Before all of this happened, Jason and I had talked a lot about how we wanted to be in each other's future. We had a lot of similar ideas about what we hoped for in a marriage and shared a lot of the same views on parenting.

Everything happened so fast. I have to say it was a difficult transition, but because we had that foundation and the same common ground, it made it a lot easier to take on all those changes at once.

Now our daughter is five, and as a family we are a strong unit. It took those difficult times for us to appreciate each other and grow closer.

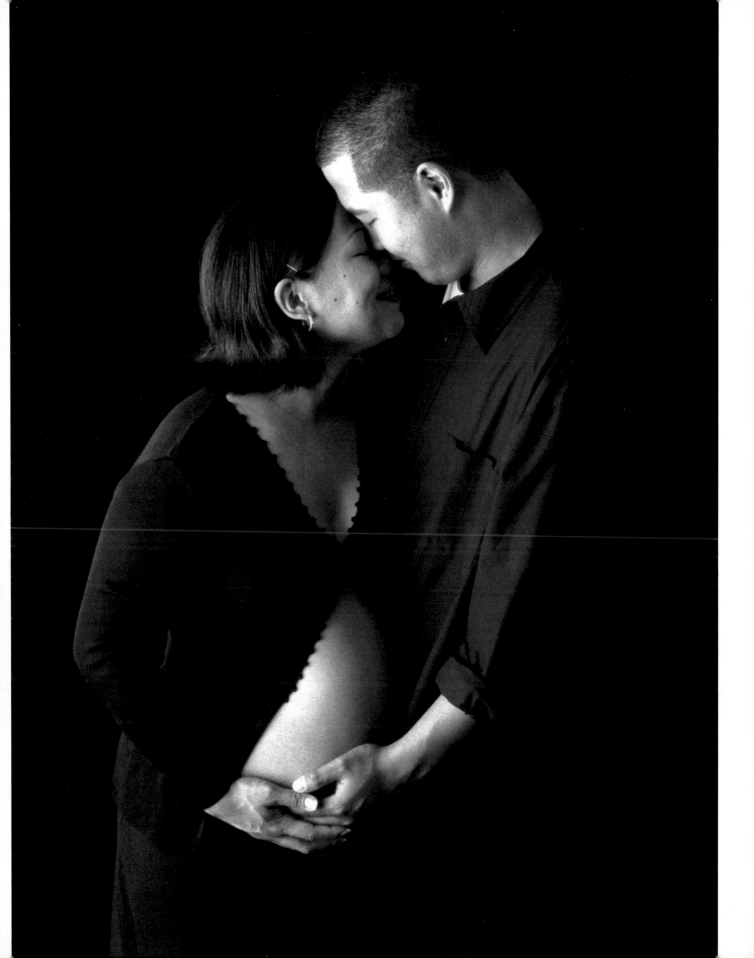

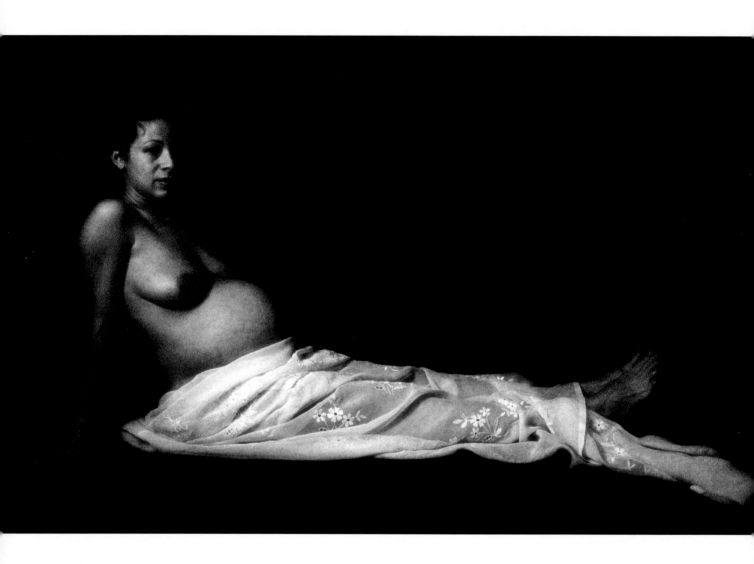

LISBETH

MY PREGNANCY INSPIRED THE BEGINNING OF A JOURNAL written to each of my children. Today, the journals are my most valued material treasures. They begin the first day I find out I am pregnant and continue to the present. I write about our journey together through the pregnancy, their life growing as little people, my life, and the lessons it has taught me. When they become adults, I will pass on these journals to them.

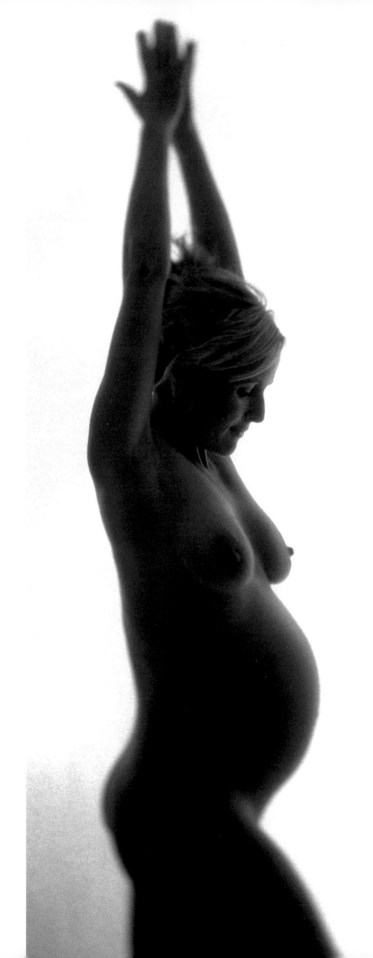

WHAT BEGAN AS SOMETHING OF A HOBBY FOR CHRISTIN TURNED into a million dollar company. She was the founder and president of a successful, organic skin care company. She loved her job and was filled with a sense of purpose. But when she was forty, she decided to sell her company and become a mother. To her surprise, she discovered that getting pregnant was the easy part.

CHRISTIN

SINGLE WELL INTO MY THIRTIES, I HAD LONG SINCE MADE PEACE WITH THE possibility that I wouldn't have children. It's not that I was indifferent to motherhood. I knew from my relationship with my mother that the love between a mother and child was unfathomable and beyond comparison. But if life was a series of tradeoffs, I figured I had done pretty well. I had found my calling after all.

The hobby I began on my kitchen table ended up in some of the most exclusive boutiques in Hollywood. The company was my greatest passion and, in a way, my baby. It was a very special time in my life. I had the feeling that comes with knowing you're doing exactly what you should be doing. But even as I assured myself I would be fulfilled without children, I also thought it would be sad if I didn't get to experience motherhood.

I wanted to be a mother, but not above all else. For instance, I knew I didn't want to have a baby alone or with the wrong person. Part of the joy I imagined was experiencing a child with someone I loved. I grew up without my dad and if I had a child, I wanted him or her to have both parents. Then, I met Phil.

I was almost forty. He was twelve years older than I and didn't have kids either. Meeting him turned my hypothetical desire for motherhood into a true longing. But given my age, we knew we didn't have time to waste. Within months I sold my company and became pregnant.

I never would have guessed that getting pregnant would be easier than being pregnant. For the most part, I knew what to expect physically: the nausea, the weight gain, the

hormonal changes. But what I wasn't prepared for was the loss of my identity. What should have been a time of celebration became a time of conflict.

My successful, happy life was one that I had created. To have a baby was my decision, too. But in an effort to create this next phase of my life, I unintentionally lost my tether, my direction, my sense of purpose. I had set myself adrift in unfamiliar territory. I was no longer the head of the company. I gave up the title, the business cards, and my place in the world as I knew it. I suddenly found myself very anxious.

This process that I had set in motion couldn't be reversed or negotiated. Intellectually, I knew that. But emotionally it was hard to accept. I felt unequipped to do what pregnancy required of me, to wait, to be present, and to relinquish control.

At first, I felt lost, then depressed, and finally helpless. Gradually, through the fog, it became clear that I had to be the one to find my way out. Maybe I couldn't control everything, but I had made a career out of making decisions and taking action. This was no different.

First, I just accepted the extra time for what it truly was, a gift and an opportunity. I continued with something I knew—yoga. I dove into my classes. I meditated. I took long walks every morning on the trails around my home. At the top of the hill, I'd take a deep breath, remind myself to be thankful for living in this beautiful place, and I'd walk back down. Walking always helped move things around in my head. It helped me think positively about whatever outcome the world had in store for me. The depression abated, and I began to relish my changing body and the life it was supporting.

The other me, the entrepreneur, is still there. I will always be that person even if, right now, motherhood has taken over. I love ideas. I love contributing and giving the world something it needs. It's a big part of what I am. Now, so is my daughter, Eden. Eventually, I will have to figure out how to be a mom and an entrepreneur. But not right now. Now that Eden has arrived, it can wait.

I never would have guessed that getting pregnant would be easier than being pregnant. For the most part, I knew what to expect physically: the nausea, the weight gain, the hormonal changes. But what I wasn't prepared for was the loss of my identity.

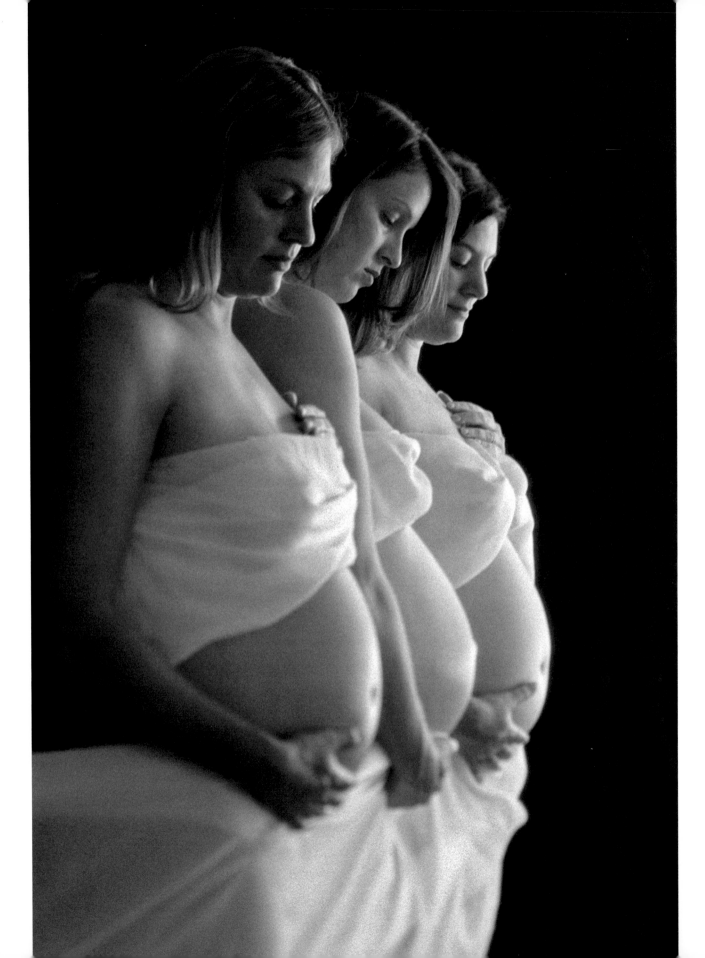

TERESA

As SISTERS, IT WAS VERY SPECIAL FOR US TO GO THROUGH our first pregnancies together. It was fun bonding over the changes in our bodies. Our babies were born within one month of each other and the cousins are still very close.

CASEY

My husband and I met at work and he proposed to me four months after our first date. He is such a caring and loving man. Throughout my entire pregnancy, it was all about me, my comfort, my happiness, and my health. He would always surprise me with little things like going to the store and getting me chocolate milk without me asking. It was the little things that I absolutely loved. It didn't have to be anything big. The little, simple, thoughtful gestures meant the most to me.

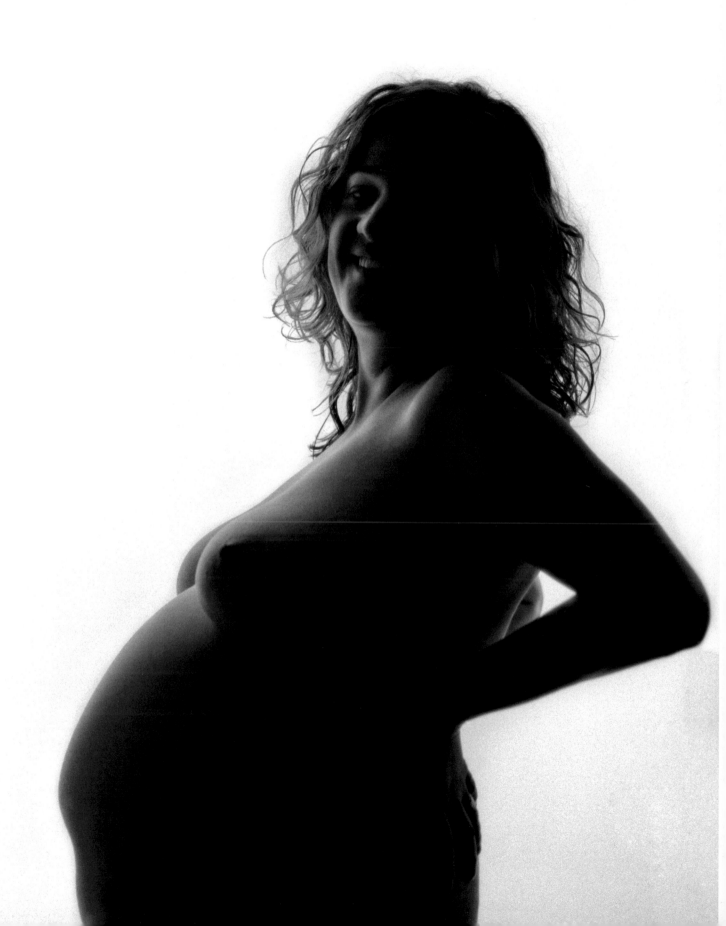

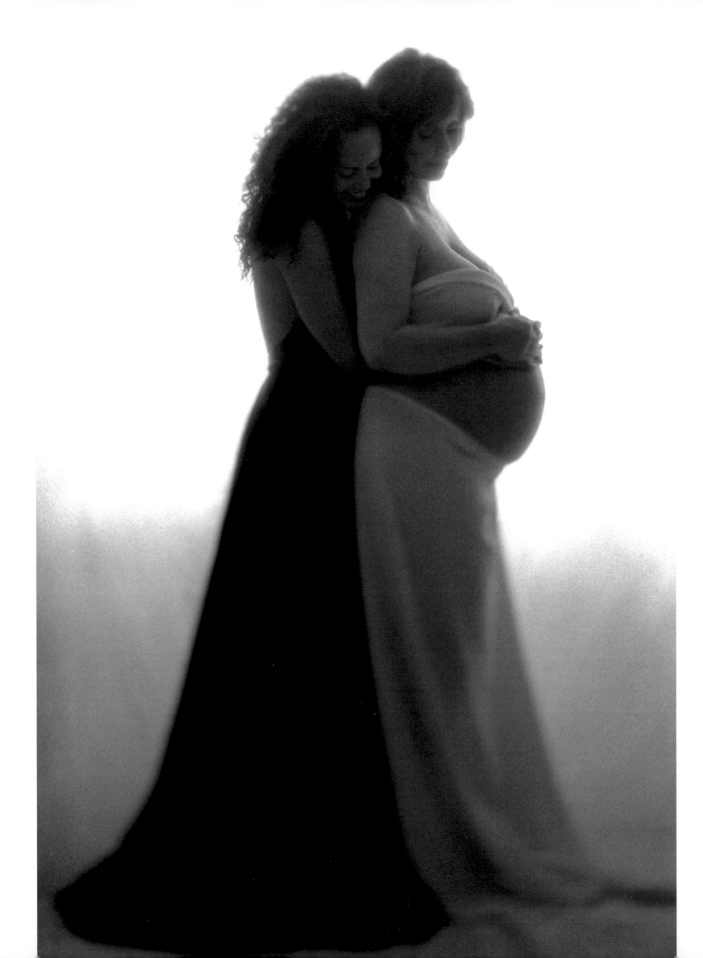

ALETA

I ALWAYS KNEW I WAS GOING TO HAVE CHILDREN. MY GRANDMOTHER had my mother at fifty-four so I never felt that there was a rush. There were many things that I wanted to do in terms of discovering myself. I traveled the world. I had a successful show business career that led to a path of self-discovery, and then to my decision to become a healer and help others transform and heal their lives.

I met my spiritual daughter, Lauren, when she was ten years old. From the beginning we had a very strong connection. I became like a second mother to her and she was a soul daughter to me. At forty-nine, I realized that I should get started on having a family of my own. I really felt like I had done everything I needed to do and was now at a place in my life where I could give my wisdom, love, and devotion to my own children. As I was a support to Lauren in her quest to become a young woman, she was a wonderful support to me through my process of becoming a mother. She has always loved the twins like they were her own brother and sister. We are like a spiritual family for her, as she is for us.

TASHA HAD BEEN MARRIED FIVE YEARS TO HER HUSBAND KAMAL WHEN she discovered a baby was on the way. When Tasha and Kamal first met, they were instantly attracted to each other and were certain that they made a perfect match. They loved each other's company—even enjoyed running a successful business together. They looked forward to the joys and challenges of being parents, but were not sure how this new phase of their journey together would affect their close and happy relationship.

TASHA

KAMAL AND I REALLY LIKE BEING TOGETHER. WE'VE TRAVELED TO MANY wonderful places and had a lot of fun times as a couple. Before our daughter, Khaysia Starr, came into our lives, we often took off to explore the world on a moment's notice. While we knew that at some point we'd be enthusiastic and devoted parents, it was fun being carefree while we could. Looking back, I cherish the time I had alone with my husband and feel that our adventures made us a stronger couple. As it turned out, we didn't pick the moment that our lives would change, but when it happened, we adjusted quickly and embraced our new roles.

Kamal and I had been planning a much-anticipated trip to beautiful Hawaii when I discovered I was pregnant—a big shock for us both. When I called my husband to tell him he was going to be a father, I was overwhelmed with emotion. I remember him asking me, "What's wrong? Were you in an accident?" All I could manage to say through my tears was, "I'm not ready, I'm not ready!" When he calmed me down and I told him I was pregnant, he said, "Why are you crying? Isn't that a good thing?" Kamal assured me that even though I'd be five months pregnant on our vacation, we would still go to Hawaii. Our impending parenthood made us both anxious, but we knew we were solid in our relationship and ready to fully love and support the new addition to our lives.

The pregnancy was difficult for me for the first few months—pretty much all I could eat was oatmeal, rice, and Captain Crunch. To this day, I don't eat Captain Crunch anymore! In contrast, however, the actual birth was not too difficult. My labor was only four

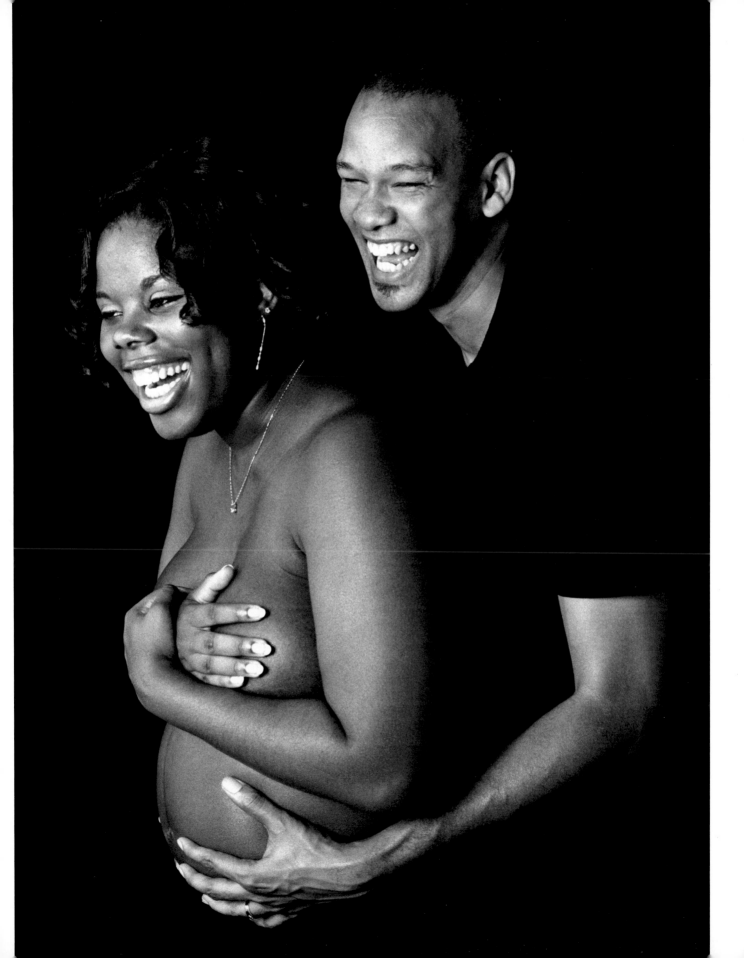

Our impending parenthood made us both anxious, but we knew we were solid in our relationship and ready to fully love and support the new addition to our lives.

hours long, and my beautiful daughter arrived after just four pushes. During my pregnancy I had been concerned about how difficult labor and delivery might be, but as is so often the case, the things I worried about were manageable in the end.

When I was pregnant, another mother gave me some good advice that I would like to pass along: Make sure that you and your husband take time for yourselves within the first month of your baby's life—even if you just sit in the car and listen to music. The first time I had to leave my daughter with someone else was hard for both of us. However, it was extremely important for me to realize that the world would not end if Khaysia and I were apart. I treasure time with my little one, but also appreciate the fact that Kamal and I still have date nights, just the two of us. It's very important for our marriage to have that time together.

We still travel frequently, with our daughter in tow. We're blessed with a non-fussy baby who loves to travel as much as we do—she flew on an airplane eight times before she turned one! Kamal and I have taken the growth of our family in stride, but it certainly helps that Khaysia is such a calm baby. Having her along on our travels gives our adventures an added dimension, as we build family memories. I have discovered that I can stay connected to my husband while being a great mom and a busy businesswoman. Balance is possible!

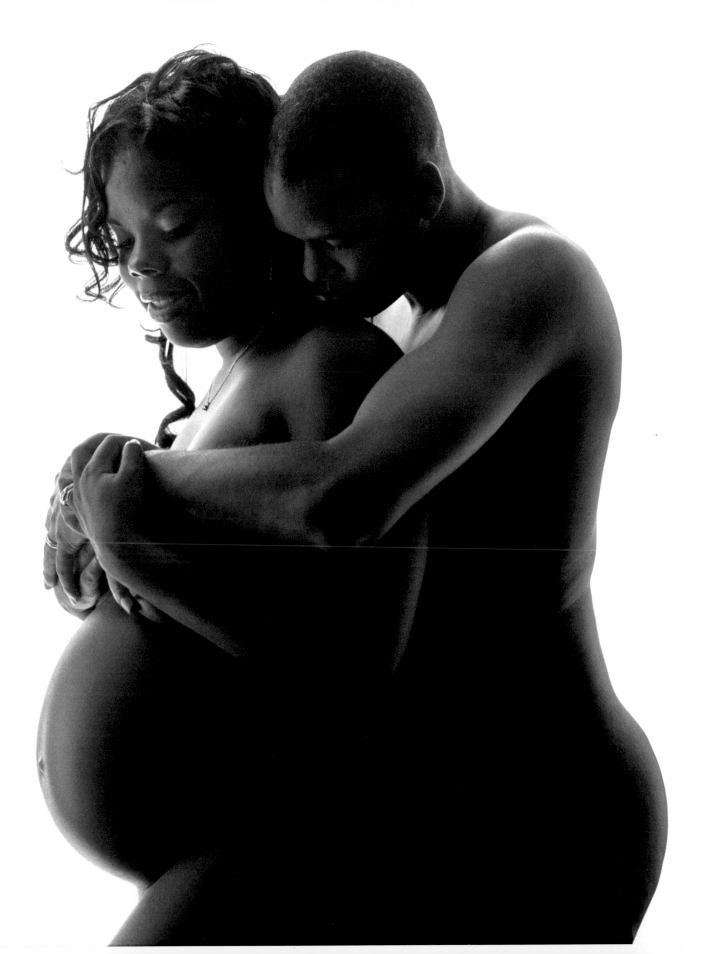

MICHELLE

MIKAELA AND I NEVER FELT SO CLOSE AS WE DID during my pregnancy with our miracle baby, Matthew, who was conceived just six weeks after the traumatic loss of our baby girl. We felt so blessed by this pregnancy we wanted to share the joy of our new baby, son, and brother.

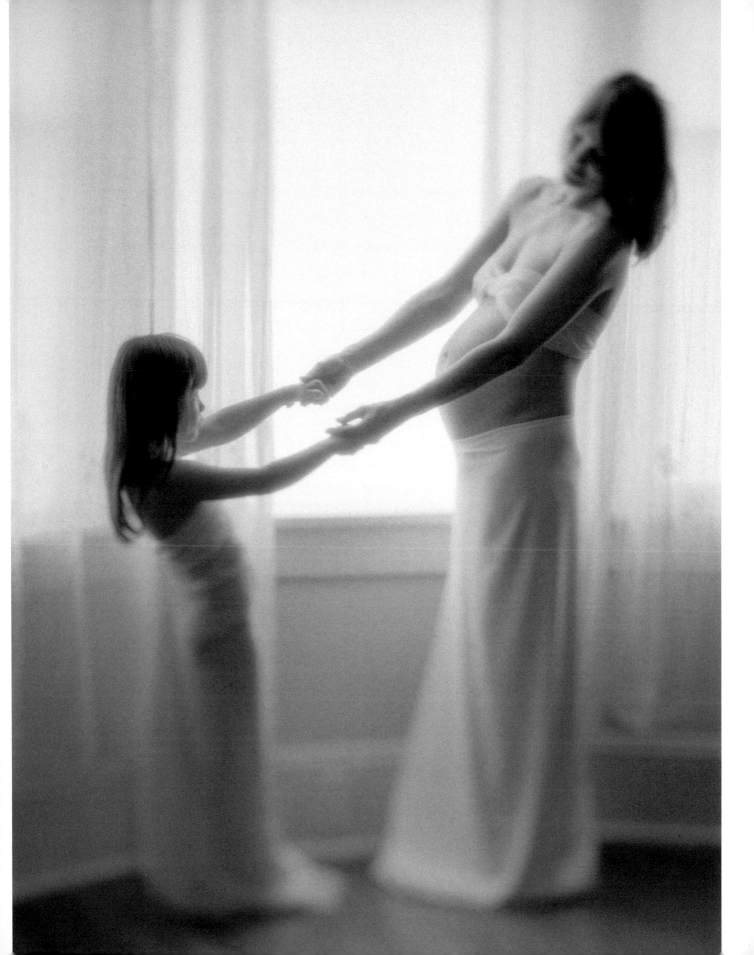

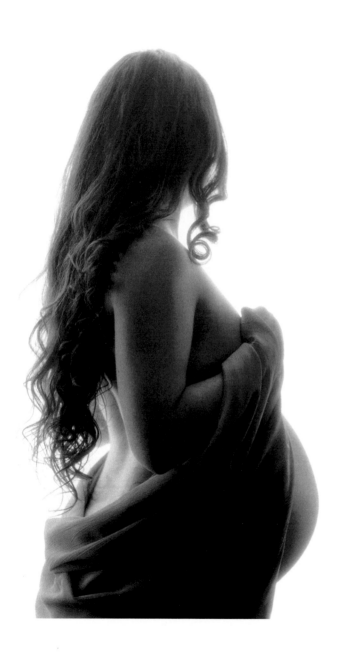
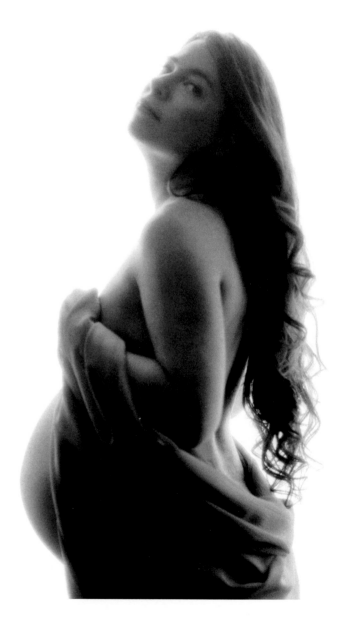

LAURA

E TRIED TO GET PREGNANT FOR OVER TWO YEARS, BUT it just wasn't happening. So I figured never mind, maybe this isn't for us. Let's try something else. So I bought a new sports car. Literally two weeks after that I found out I was pregnant. It happened almost instantly, the moment we let go and stopped trying. We were so excited. After we found out it was a girl, we named her Adia, which is Swahili for "gift from god."

JENNIFER

THEY TOLD ME TO PUSH—I PUSHED HARD—TWICE THROUGH contractions. They shouted to me that we, you and I, were doing great. I was on fire down there—a taut circle of muscle between you and the world. It was the ring of fire and I was tearing but I did not care. You were coming, you were coming, you were coming.

You were coming into this world, my love. You were coming to breathe from out of the darkness, coming to air, coming to light. You were coming to my arms, to my kisses, to my breasts. You were coming to birthdays, memory, and heartache. You were coming to cardamom, cupcakes, and champagne. You were coming to carnelian and lovemaking and death. You were coming to weep and to shout and to dance. Coming to your voice and to love your own loves. You were coming to hear seagulls, mourning doves, crows, and cicadas. You were coming to thunder and snow and wind. You were coming to cotton, leather, and velvet. You were coming to your daddy and coming to me. You were separating from me. You were coming to your life. When they brought you to my outstretched arms, I said, "You are my child. You are my child." I kissed you and I couldn't stop looking at your face.

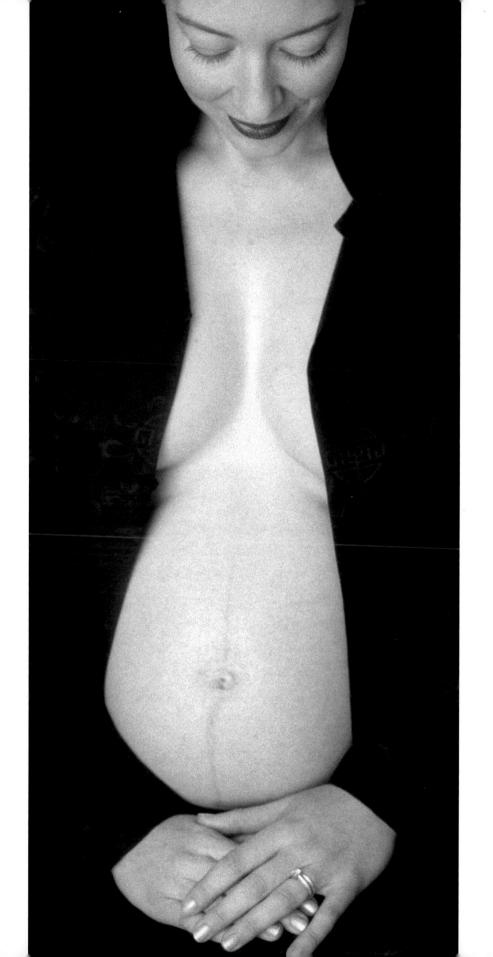

Acknowledgements

Three people are directly responsible for bringing this book to print: My amazing agent, Steve Harris, who saw an article about me and my work, cold-called me when I had the flu, and successfully talked me into working with him. I don't regret it for a minute. Thanks, Steve! My publisher, Connie Shaw, who impressed me from our very first conversation with her probing questions as she tried to discern if I was a passionate author and one who would be dedicated to my project. It has been a rewarding relationship. Connie, thanks for believing in me and the success of this book, for holding my hand during this process, and for laughing with me, not at me. And most importantly, one of the most amazing women I have ever met, Joelle Fiorito, without whom this entire project, my entire business, and I could even say my entire life, would not have run as smoothly or been as much fun as it has. She was always ready with a hilarious joke, a smile, and a laugh, even in the midst of the tsunami of deadlines and demands. Thanks, Joelle, for keeping everything fun and for caring so much about this project, my business, and me.

There are also many others. My friend Brittan Blasdel, who has loved and supported me for the past fifteen years and who keeps her heart and apartment door open any day or night. All my friends in Seattle, San Francisco, and New York whom I lived with, drank with, ate with, was welcomed by to crash on their floor, photographed, and tested different techniques on. One of my toughest but favorite photo editors, Bryan Moss, who taught me to photograph from my heart, not my head. My professors at the University of Missouri School of Journalism who taught me how to capture a moment and tell stories instead of just taking photographs. Tom Bishop, who thought what I was doing was cool enough to feature it in a television piece that launched my career. The good people at Freestyle Photographic Supply, who believed in me enough to make me a board member before maternity photography was a recognizable genre. Michelle Bates, for doing a great job of proofing the book. The dedicated Sandra Eisert, without whom the design wouldn't have been nearly as elegant and lovely. Dana, Mary, and Tammy, who have processed and printed my work for the past ten years. And finally, my dog Salvador, who reminds me daily that I really do need to go to the park.

About the Authors

Jennifer Loomis

Jennifer Loomis is an award-winning and internationally recognized fine-art photographer and photojournalist, known for her groundbreaking work with the pregnant nude. With a master's degree in photojournalism, Jennifer worked as a photojournalist for six years covering everything from the Sweet Corn Festival in Indiana to the Hutu and Tutsi reintegration in Rwanda. She worked at MSNBC.com for three years as a multimedia producer and journalist covering the Columbine massacre, the millennium, election 2000, and 9/11.

Jennifer's passion for fine art and photography began when she was an undergraduate at the University of Virginia where she took numerous art history and fine-art classes. Jennifer even considered majoring in art history before changing her degree to international politics with a minor in Asian studies. Upon graduating she moved to Japan to teach and study the language as well as work on environmental and women's issues, two of her main causes while in college. After leaving Japan, she traveled throughout Southeast Asia studying the art, food, culture, and music and completed her first ten-day silent meditation retreat at age twenty-three.

She then moved to San Francisco where she was introduced to the photography of Ruth Bernhard and Robert Mapplethorpe. She began painting and photographing the female nude and the female pregnant nude, aware of the difference of her vision from that of many of her male colleagues. In order to make a living while pursuing photography, she worked as a waitress in a sushi restaurant and as a photo assistant at a large photo studio. After seeking advice from numerous professional photographers in the Bay area, she decided that there was no market for fine-art photographs of nudes and pregnant nudes. She moved from San Francisco to enroll in a photojournalism master's program at the University of Missouri but continued her personal fine-art photography.

Jennifer got her first referrals from Annie Leibovitz's studio—where Demi Moore was photographed pregnant for *Vanity Fair*. In 2001 she decided to make the shift into photographing pregnant women full time. She now has studios in Seattle, San Francisco, and New York. Jennifer and her work have been featured in *Time* magazine, the *New York Times, Wall Street Journal, Associated Press, San Francisco Chronicle, Seattle Times, Seattle Post Intelligencer, Chicago Tribune, Sunset* magazine, *Plum* magazine, *Fit Pregnancy*, and on the *CBS Morning Show, Good Morning America*, NPR, *Inside Edition*, iVillage and numerous other websites.

Jennifer uses her fine-art background to craft a unique image and her expertise as a documentary photojournalist to tell the story of each woman and family. "More than a portrait," she says, "I want to photograph a feeling that captures and celebrates each individual woman's beauty of motherhood."

After photographing more than 1,700 women over more than fifteen years, Jennifer has not only changed society's perspective of the pregnant nude but has also given each mother a new perspective of her own body. Her clients' children are now able to articulate how they cherish the photographs depicting themselves inside their mothers.

More of her work can be seen at http://www.jenniferloomis.com.

Hugo Kugiya

Hugo Kugiya has been a newspaper journalist for twenty years, is the author of *58 Degrees North* (Bloomsbury, 2005), and was a finalist for the 2006 Washington State Book Award.

For seven years, Hugo worked as a national correspondent for two outlets, *Newsday* and the Associated Press. He has won numerous regional and national awards for his deadline and feature writing, and is known as a journalist with a writer's eye for characters, conflict, and emotion. As a feature writer at the *Seattle Times*, where he started his career, he was recognized by the Best American Sports Writing anthology for his story of a girl boxer, and by the Sunday Magazine Editors Association.

At *Newsday*, he was twice honored by the Press Club of Long Island. During his six years at *Newsday*, he was also named a finalist for the American Society of Newspaper Editors Deadline Writing Award. As a national correspondent, he was the recipient of *Newsday*'s Publisher's Award and was nominated by his paper for the Pulitzer Prize in national reporting.

Photo: Joelle Fiorito

He was named a New York–based national writer for the Associated Press in 2005, one of a rare few in the industry, privileged to fly all over the country for the best stories, getting weeks and months to research, develop, and write long-form articles.

Hugo had a keen desire to be a part of this project because of the parallels drawn between it and his personal experience. Having to divide his time between New York and Seattle, where his young daughter and her mother relocated, he has gone through many of the same emotional and intellectual struggles as some of the women in the book. He has had to deal with the loss of his long-held professional identity for the sake of something more personal, more important: choosing parenthood above all else and coping with the interruption and possibly the end of a career.

Hugo Kugiya received his B.A. from the University of Washington, where he studied philosophy and mathematics while covering the Husky football and basketball teams for the college newspaper.

Sentient Publications, LLC publishes books on cultural creativity, experimental education, transformative spirituality, holistic health, new science, ecology, and other topics, approached from an integral viewpoint. Our authors are intensely interested in exploring the nature of life from fresh perspectives, addressing life's great questions, and fostering the full expression of the human potential. Sentient Publications' books arise from the spirit of inquiry and the richness of the inherent dialogue between writer and reader.

Our Culture Tools series is designed to give social catalyzers and cultural entrepreneurs the essential information, technology, and inspiration to forge a sustainable, creative, and compassionate world.

We are very interested in hearing from our readers. To direct suggestions or comments to us, or to be added to our mailing list, please contact:

SENTIENT PUBLICATIONS, LLC
1113 Spruce Street
Boulder, CO 80302
303-443-2188
contact@sentientpublications.com
www.sentientpublications.com